COMPUTER GRAPHICS III

MORE OF THE BEST OF COMPUTER ART & DESIGN

First published in the United States of America by:
Rockport Publishers, Inc. and Allworth Press
146 Granite Street
Rockport, Massachusetts 01966-1299
Telephone: 508 546 9590
Facsimile: 508 546 7141

Distributed to the book trade and art trade
in the United States by:
North Light, an imprint of
F & W Publications
1507 Dana Avenue
Cincinnati, Ohio 45207
Telephone: (513) 531-2222

ISBN 1-56496-204-0

10 9 8 7 6 5 4 3 2 1

Art Director
Laura P. Herrmann
Design and Production
Marc English : Design Boston | Austin
Cover Image
Diane Fenster

Manufactured in Hong Kong by
Regent Publishing Services Limited

COMPUTER GRAPHICS III

MORE OF THE BEST OF COMPUTER ART & DESIGN

DISTRIBUTED BY NORTH LIGHT BOOKS · CINCINNATI, OHIO

ROCKPORT ALLWORTH EDITIONS

ROCKPORT PUBLISHERS, INC. | ALLWORTH PRESS

GRAPHIC DESIGN

CORPORATE IDENTITY

FINE ART

PACKAGE DESIGN

ILLUSTRATION

CONTENTS

8

44

66

80

106

FOREWORD

by

Don Sparkman

This third volume in the series showcases the incredible speed with which computers have reshaped the face of graphic design. The profession has made some severe changes in direction: Some for the good and others that were not so good. The first book in the Computer Graphics series looks like almost everything was designed on a computer. The second book looks as though half the work were done on a computer, and the work in this volume, even less.

The "computer-look" isn't all bad, though. Companies like IBM, MCI and others want to look like they are in the twenty-first century and want the electronic look. When you look at the paintings of the old world masters, you see that they hid all traces of their brushwork. In contrast, impressionist artists used their brushstrokes as a texture in their paintings. Like brushwork, the computer's special effects are often a necessary part of the picture.

A quick look at the history of our company illustrates the impact computers have had on design. In 1985 we were a pioneer of computerized graphic design. We bought a Lightspeed DS-10, and were truly on the leading-edge of the technology. I was invited to speak about "computers in design" all over the country by various professional groups and associations.

We learned early to put the computer in perspective. For four years, we wouldn't let our designers physically use the system. We hired a young man who had a background in painting and music, and he became our "Pin-ball Wizard". The designers would think-out their solutions/designs at their desk, and bring the rough sketch to the

Lightspeed operator. They would sit next to him while he would build the page. The results were remarkable and often award-winning.

As the software improved, I saw the writing on the wall. The Lightspeed was a layout tool and although it produced dazzling thermal prints and slides of page layouts, the final mechanical had to be done from scratch. The layouts produced on the Macintosh were sent to an image-setter. This meant we could cut our labor by half. By 1992 each designer had a Mac 2CI. We bought a color scanner, 300DPI printer and within a year, everyone was networked. Because the Macs were slower and not as sophisticated as the Lightspeed, we didn't win as many awards as in the past. I know the quality of our design was down, but so was our competitors'.

We're back to designing, and the computer is just another tool. Well, not quite. With Quadra computers and Power PCs, QuarkXPress, Photoshop and Illustrator, we can now do things we never dreamed of. But with the words "computer design" there's only one word that counts. That word is "design".

Computer Graphics 3 shows the next level of transition within the graphic design industry. The work here is less driven by the medium and thus solves visual problems with design rather than gimmicks. The fourth volume in this series is bound to reveal another level of sophistication, as the field moves toward multimedia design. Believe it or not, the computer is still in its infancy.

About Don Sparkman

Don Sparkman is a past-president of the International Design by Electronics Association (IDEA). He is also a past-resident of the Art Director's Club of Metropolitan Washington (ADCMW). He has written articles for STEP BY STEP magazine on THE ECONOMICS OF COMPUTER DESIGN and THE BUSINESS OF GRAPHIC DESIGN. Don has just completed two books: THE DESIGN & PRINTING BUYER'S SURVIVAL GUIDE and SELLING GRAPHIC DESIGN, both published by Allworth Press, NY. He also developed the GRAPHIC DESIGN TRADE CUSTOMS.

His company, Sparkman + Associates, has produced award-winning computer design for: Black & Decker; Eckerd Drugs; Fortran Communications; GE; ICF International; Marriott Corporation; Mobil Oil; MCI; NASA; Rubbermaid; and many more. He is currently on the board of directors of the ADCMW and a member of American Institute of Graphic Arts (AIGA).

WINTER 94/95

Catch the spirit
der Kurs für Anfänger

get the basic moves !
only for beginners !

Power park
der Kurs für Fortgeschrittene

only for advanced !
unlimited fun and action !

1/2 Tag day öS 450.-

3 x 1/2 Tag day öS 1.100.-

5 x 1/2 Tag day öS 1.400.-

Privatstunde privat lesson öS 450.-

jede weitere Person öS 100.-
each additional person

Snowboardverleih Snowboard rental

Sondertarif für Kursteilnehmer
special rate for course participants

INFOS and BOOKING:
Toni's Schischule
A-5600 St. Johann/Pg., Alpendorf 2
(Alpendorf Kabinenbahn - cablecar station)
Tel. 0 64 12 / 79 27
Fax 0 64 12 / 83 22

DESIGN

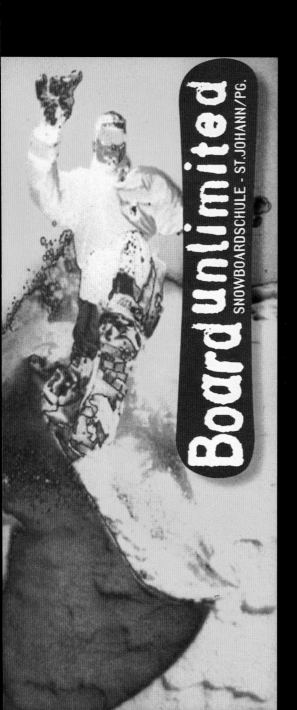

Promotional Flyer
Design Firm **Modelhart Grafik Design**
All Design **Herbert O. Modelhart**
Client **Board Unlimited Snowboard School**
Software **Adobe Photoshop, Adobe Illustrator, QuarkXPress**
Hardware **Power Macintosh 7100/66**

Photographs were manipulated in Photoshop. Other graphic elements were produced in Illustrator and QuarkXPress.

10

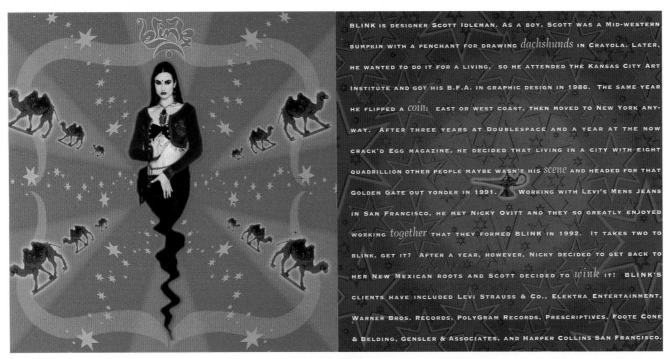

BLINK IS DESIGNER SCOTT IDLEMAN. AS A BOY, SCOTT WAS A MID-WESTERN BUMPKIN WITH A PENCHANT FOR DRAWING *dachshunds* IN CRAYOLA. LATER, HE WANTED TO DO IT FOR A LIVING, SO HE ATTENDED THE KANSAS CITY ART INSTITUTE AND GOT HIS B.F.A. IN GRAPHIC DESIGN IN 1986. THE SAME YEAR HE FLIPPED A *coin*: EAST OR WEST COAST, THEN MOVED TO NEW YORK ANYWAY. AFTER THREE YEARS AT DOUBLESPACE AND A YEAR AT THE NOW CRACK'D EGG MAGAZINE, HE DECIDED THAT LIVING IN A CITY WITH EIGHT QUADRILLION OTHER PEOPLE MAYBE WASN'T HIS *scene* AND HEADED FOR THAT GOLDEN GATE OUT YONDER IN 1991. WORKING WITH LEVI'S MENS JEANS IN SAN FRANCISCO, HE MET NICKY OVITT AND THEY SO GREATLY ENJOYED WORKING *together* THAT THEY FORMED BLINK IN 1992. IT TAKES TWO TO BLINK, GET IT? AFTER A YEAR, HOWEVER, NICKY DECIDED TO GET BACK TO HER NEW MEXICAN ROOTS AND SCOTT DECIDED TO *wink* IT! BLINK'S CLIENTS HAVE INCLUDED LEVI STRAUSS & CO., ELEKTRA ENTERTAINMENT, WARNER BROS. RECORDS, POLYGRAM RECORDS, PRESCRIPTIVES, FOOTE CONE & BELDING, GENSLER & ASSOCIATES, AND HARPER COLLINS SAN FRANCISCO.

Promotion
Design Firm **Blink**
All Design **Scott Idleman**
Client **Self-promotion**
Software **Adobe Workshop, QuarkXPress**
Hardware **Macintosh Centris 650**

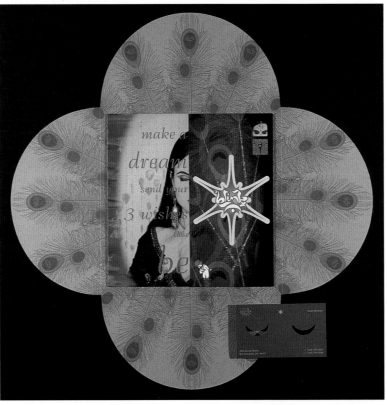

Promotion
Design Firm **Blink**
All Design **Scott Idleman**
Client **Self-promotion**
Software **Adobe Photoshop, Adobe Illustrator, QuarkXPress**
Hardware **Macintosh Centris 650**

The peacock feathers on the envelope and the piece itself were taken from an Illustrator document, brought into Photoshop, and manipulated with filters.

Book Cover
Design Firm **Blink**
All Design **Scott Idleman**
Client **Manic D Press**
Software **Adobe Illustrator,**
Adobe Photoshop,
QuarkXPress
Hardware **Macintosh**

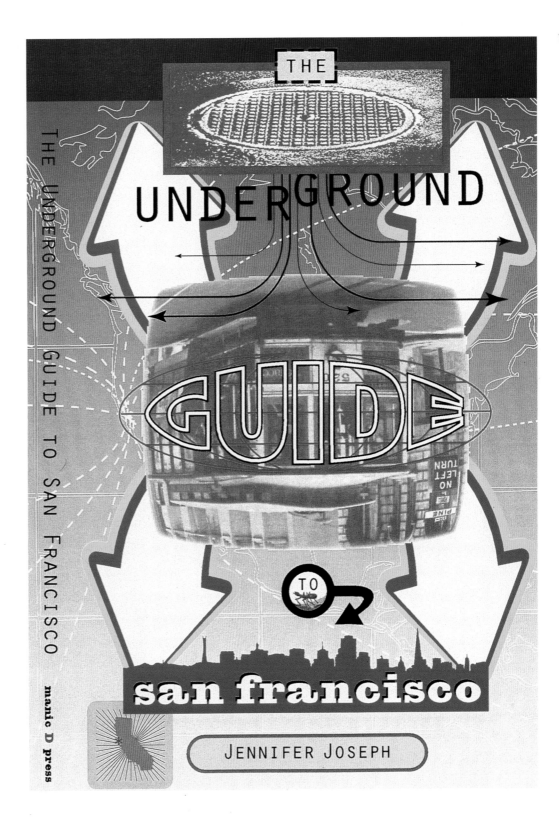

12

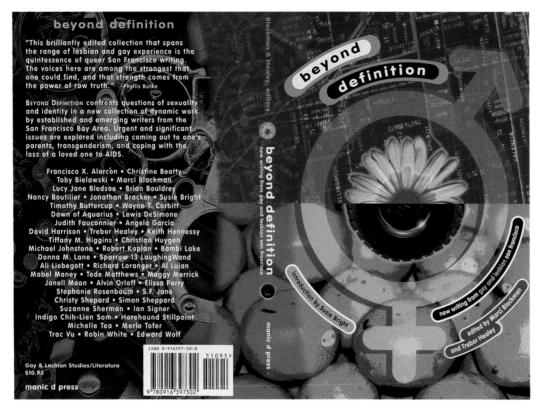

Book Cover
Design Firm **Blink**
All Design **Scott Idleman**
Client **Manic D Press**
Software **Adobe Photoshop,
QuarkXPress**
Hardware **Macintosh Centris
650**

The background image began
as a one-piece collage in
Photoshop made up of bad
snapshots that were scanned
and colorized.

Annual Report
Design Firm **Clifford Selbert
Design Collaborative**
Art Director **Lynn Riddle**
Designers **Iesa Figueroa,
Robert Merk, Lynn Riddle**
Client **Avid Technology, Inc.**
Software **QuarkXPress, Adobe
Illustrator, Adobe Photoshop**
Hardware **Macintosh Quadra
840 AV**

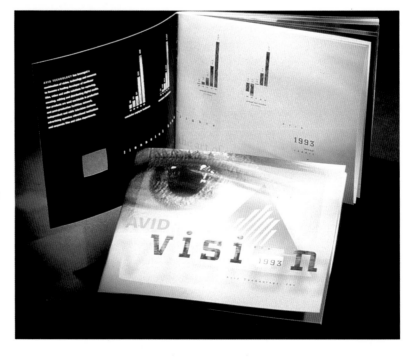

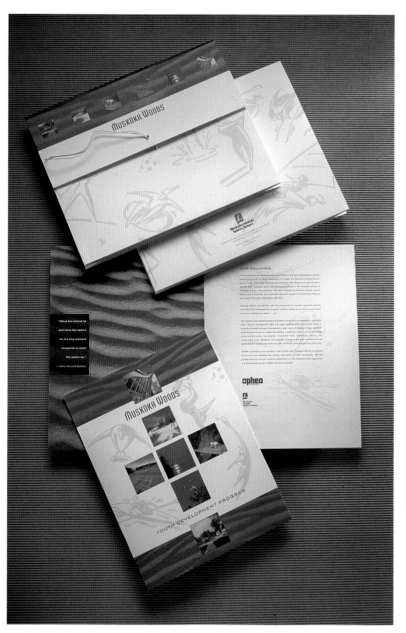

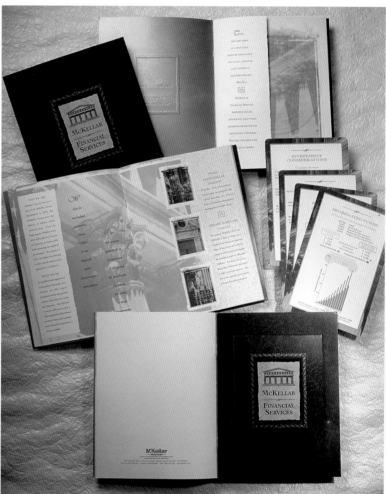

Muskoka Woods Sports Resort Curriculum Brochure
Design Firm **The Riordon Design Group Inc.**
Art Director **Ric Riordon**
Designer **Dan Wheaton**
Client **Self-promotion**
Software **QuarkXPress, Adobe Photoshop, Adobe Illustrator**
Hardware **Macintosh Quadra 840 AV, Power Macintosh 8100**

The design was created with the use of QuarkXPress, Illustrator, and Photoshop and was printed 4-color on recycled paper.

McKellar Corporate Brochure
Design Firm **The Riordon Design Group Inc.**
Art Director **Ric Riordon**
Designer **Dan Wheaton**
Client **Self-promotion**
Software **QuarkXPress, Adobe Photoshop**
Hardware **Macintosh Quadra 840 AV, Power Macintosh 8100**

A simulated leather look was created with a combination of a textured double hit of ink, pearl foil stamping, embossing, gloss and matte varnish used on text elements, and Phoenix Imperial cover stocks.

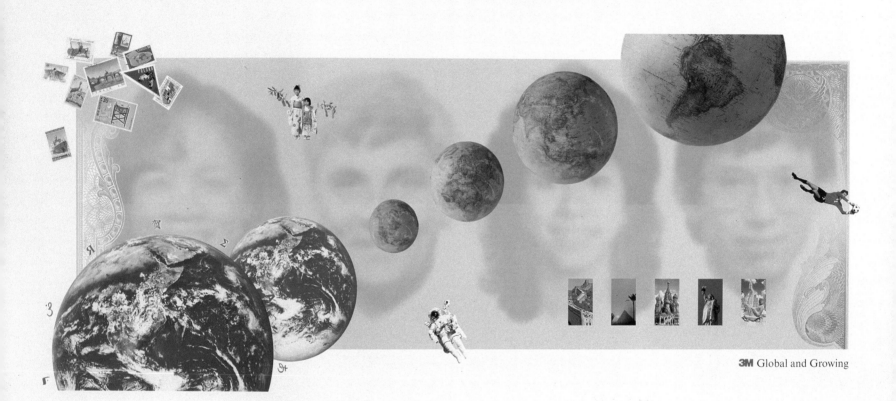

3M Global and Growing

Advertisement Poster
Design Firm **Martin Ross**
Design
All Design **Ross Rezac, Martin**
Skoro
Client **3M**
Software **QuarkXPress, Adobe**
Illustrator, Adobe Photoshop
Hardware **Macintosh II CI**

The satellite globe form
was transformed into a geo-
political globe by decreasing
the opacity of the image.

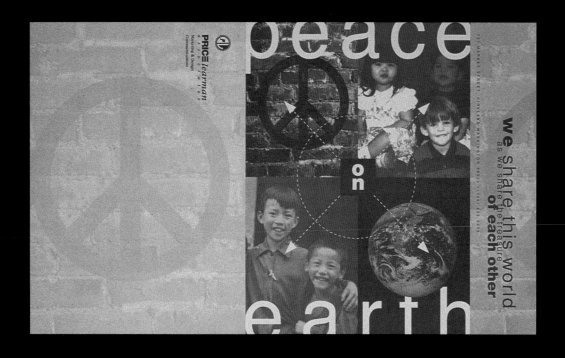

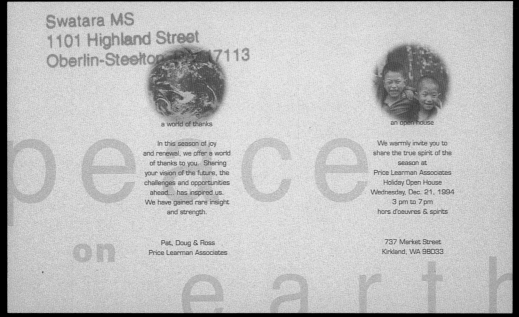

Invitation
Design Firm **Price Learman**
Associates
Art Directors **Ross West, Patricia**
Price Learman
Designer **Ross West**
Client **Price Learman Associates**
Software **Aldus Freehand 4.0,**
Adobe Photoshop
Hardware **Macintosh Quadra 650**

Numerous scanned photographs
were combined and manipulated
in Photoshop to achieve the
desired effects. All Photoshop
images were saved as TIFFs,
imported into FreeHand, and
combined with text and graphics.

**EFC Environmental Action
Brochure**
Design Firm **The Riordon
Design Group Inc.**
Art Director **Ric Riordon**
Designers **Dan Wheaton,
Meredith Garre**
Client **The Riordon Design
Group Inc.**
Software **QuarkXPress, Adobe
Photoshop**
Hardware **Macintosh Quadra
840 A, Power Macintosh 8100**

All of the cover graphics for
this brochure were developed
in QuarkXPress. The 4-color
cover and the 2-color interior
were printed on Byronic recy-
cled cover.

Promotional Book
Design Firm **The Riordon
Design Group Inc.**
Art Director **Ric Riordon**
Designer **Dan Wheaton**
Client **Self-promotion**
Software **QuarkXPress, Adobe
Photoshop**
Hardware **Macintosh Quadra
840 AV, Power Macintosh 8100**

This elaborate design used
metallic foil stamps, metallic
inks, embossing, and a wind-
stone, marble vellum insert.

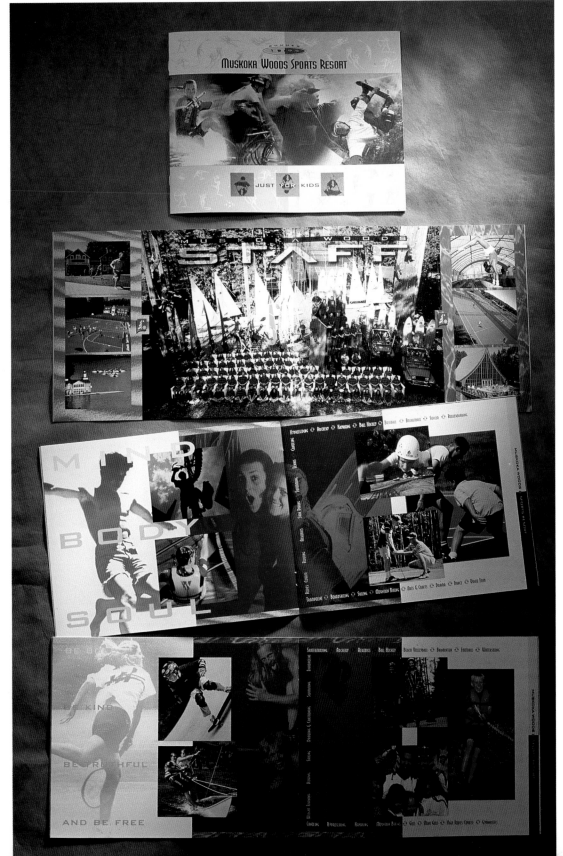

**Muskoka Woods Sports Resort
Summer Brochure**
Design Firm **The Riordon
Design Group Inc.**
Art Director **Ric Riordon**
Designer **Shirley Riordon**
Client **The Riordon Design
Group Inc.**
Software **QuarkXPress, Adobe
Photoshop**
Hardware **Macintosh Quadra
840 AV, Power Macintosh 8100**

Photoshop montages, duo-
tones, and 4-color pictures
were combined for this
dynamic layout.

18

Promotional Sales Kit
Design Firm **Hornall Anderson**
Design Works
Art Director **John Hornall**
Designers **John Hornall, Lisa**
Cerveny, Suzanne Haddon
Client **GE/GNA Capital**
Assurance
Software **QuarkXPress, Aldus**
FreeHand
Hardware **Power Macintosh**
8100/1000

The design process included a
three-dimensional tactile
approach to make this product
stand out from its competi-
tors' promotions.

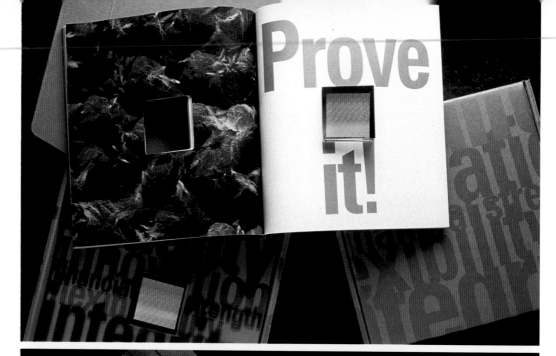

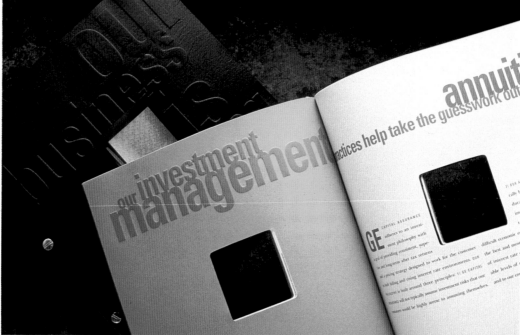

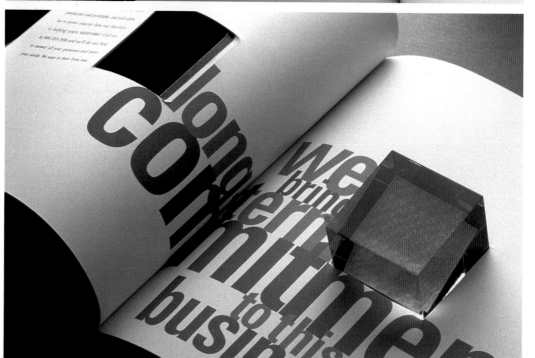

Annual Report
Design Firm **Hornall Anderson Design Works**
Art Director **John Hornall**
Designers **John Hornall, Lisa Cerveny, Suzanne Haddon**
Client **Airborne Express**
Software **QuarkXPress, Aldus FreeHand, Adobe Photoshop**
Hardware **Power Macintosh 8100/1000**

A paper collage representing different business areas was photographed and merged in Photoshop with an existing airborne photograph of clouds. The collage image was then scanned in a 4-color process and clouds were added as a warm quadtone. The shadow on the plane was later added in Photoshop.

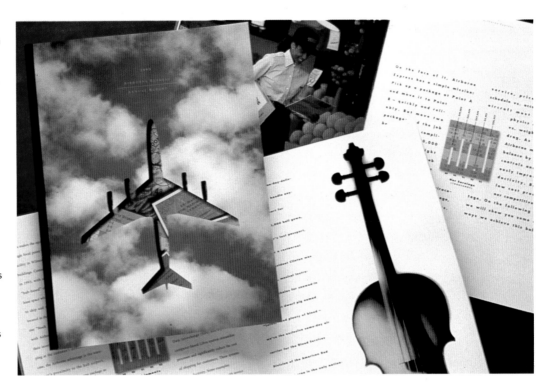

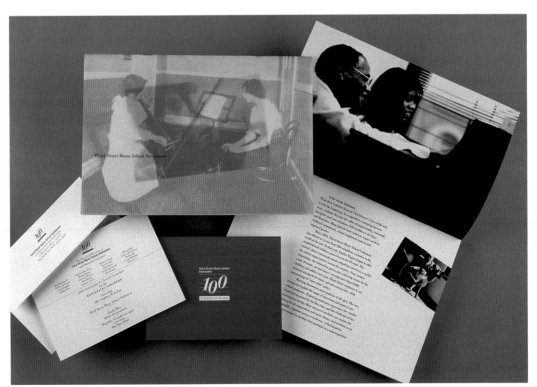

Promotional Brochure
Design Firm **Richard Danne & Associates**
All Design **Richard Danne**
Client **Fashion Institute of Technology**
Software **QuarkXPress, Adobe Illustrator, Adobe Photoshop**
Hardware **Macintosh Quadra 800**

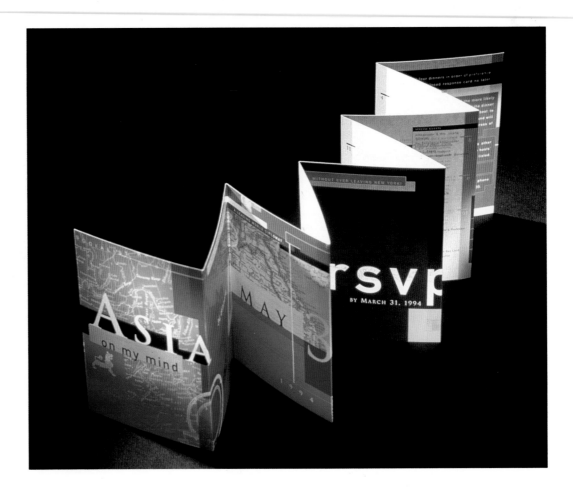

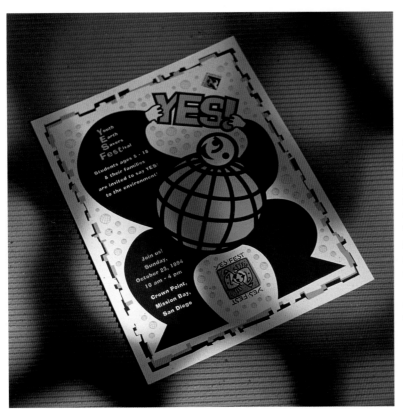

Poster
Design Firm **Steven Morris Design**
Art Director **Steven Morris**
Designer **Steven Morris**
Client **San Diego Earth Day, Yes! Fest Poster**
Software **Adobe Illustrator**
Hardware **Power Macintosh 6100/60**

All art for this festival poster was hand-rendered in Illustrator.

Invitation
Design Firm **Clifford Selbert Design Collaborative**
All Design **Darren Namaye**
Client **The Asia Society**
Software **QuarkXPress**
Hardware **Macintosh Quadra 950**

Traditional and dull-opaque inks were used in this design. One-sided castcoated stock allowed for subtle contrasts in visual and physical tactility, while overprinting created a layered effect.

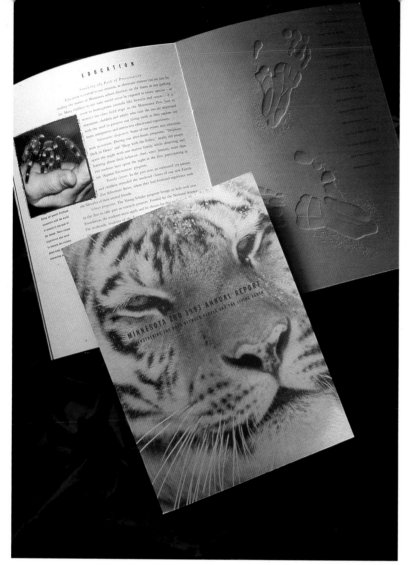

Annual Report
Design Firm **Rapp Collins Communications**
All Design **Bruce Edwards**
Client **Minnesota Zoo**
Software **QuarkXPress, Adobe Photoshop**
Hardware **Macintosh Quadra**

Photographs were scanned into the computer and duo-toned in Photoshop.

Poster
Design Firm **Mike Salisbury Communications**
Art Director **Mike Salisbury**
Designers **Mike Salisbury, Ron Brown**
Illustrator **Ron Brown**
Client **Gramercy Pictures**
Software **Adobe Photoshop 3.0**
Hardware **Macintosh Quadra 950**

This entire piece, including lay-out, cube art, photo and color effects, backgrounds, and the title, was created on the computer.

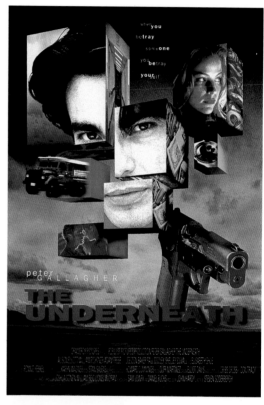

Sculptor's Brochure
Design Firm **Veronica Graphic Design**
All Design **Veronica Tasnadi**
Client **Marte Szirmay**
Software **CorelDraw 4.0, Aldus PageMaker 5.0**
Hardware **IBM 486 DX33 170, 8RAM**

The designer included pocket folders with this brochure and used sheet-fed lithographic printing.

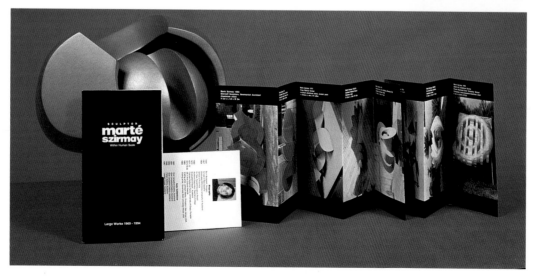

22

Poster
Designer **David Posey**
Client **Self-promotion**
Software **Aldus FreeHand 4.0**
Hardware **Power Macintosh**

T-Shirt
Design Firm **Bach Design Ltd**
All Design **Steve Krupsky**
Client **Millhouse/McCabe**
Software **Adobe Illustrator**
Hardware **Macintosh Quadra**
650

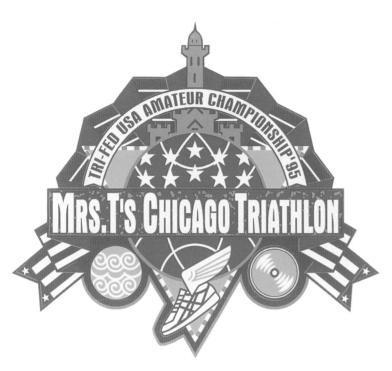

Tri-Fed Triathlon Logo
Design Firm **Jim Lange Design**
Art Director **Jan Caille**
Designer **Jim Lange**
Client **Mrs T's Perogies**
Software **Adobe illustrator**
Hardware **Macintosh II C 1**

A tight pencil drawing was
used as a template for this
design. The logo itself was
then drawn on computer.

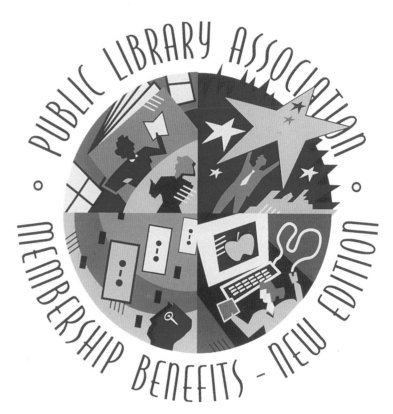

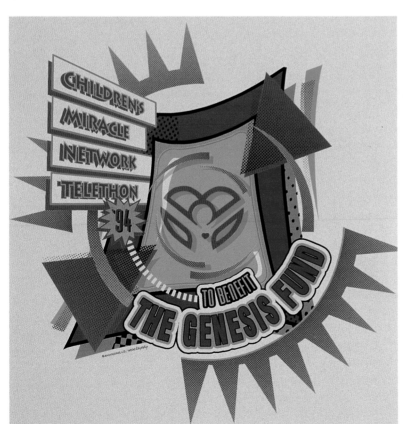

T-Shirt
Design Firm **Bach Design Ltd.**
All Design **Steve Krupsky**
Client **The Genesis Fund**
Software **Adobe Illustrator,
Aldus FreeHand**
Hardware **Macintosh Quadra
650**

**Membership Benefits Brochure
Cover Logo**
Design Firm **Jim Lange Design**
Art Director **Sandy Garrison**
Designer **Jim Lange**
Client **Public Library
Association**
Software **Adobe Illustrator**
Hardware **Macintosh II C 1**

This design was completely
drawn on Macintosh with
Illustrator and the logo was
printed 3-color.

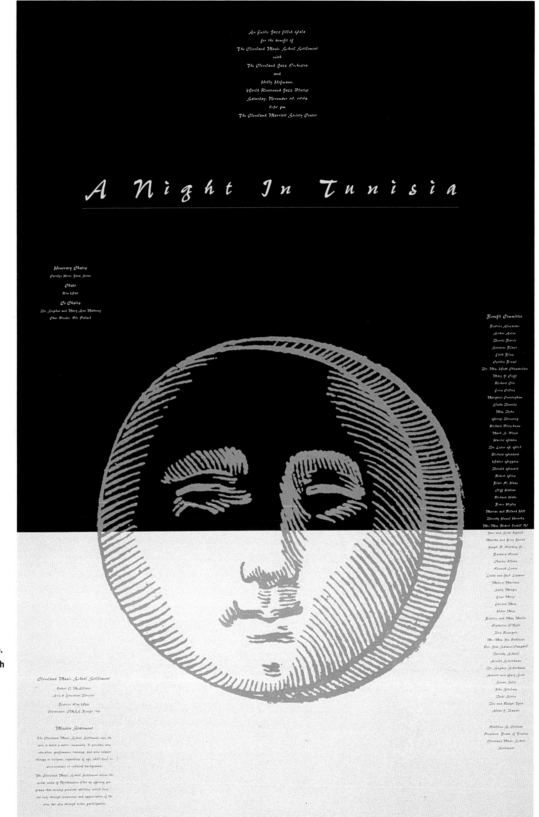

Poster
Design Firm **Watt, Roop & Co.**
Art Director **Gregory Oznowich**
Illustrator **Clip art**
Client **The Cleveland Music School Settlement**
Software **Aldus PageMaker 5.0**
Hardware **Macintosh Quadra 950**

The graphic was only 1.3 cm in height. It was scanned at high resolution then re-sized in PageMaker. The edges were intentionally left rough.

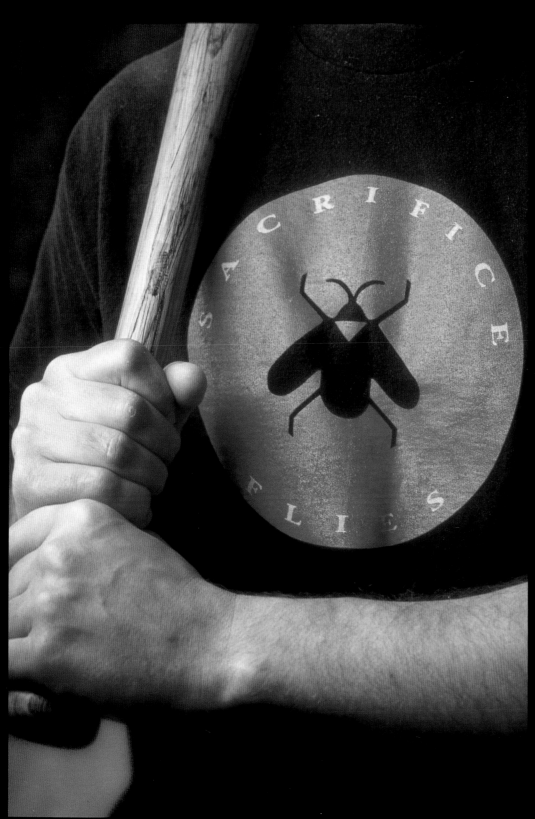

T-Shirt
Design Firm **Rapp Collins**
Communications
All Design **Bruce Edwards**
Client **Rapp Collins**
Communications
Software **Adobe Illustrator**
Hardware **Macintosh FX**

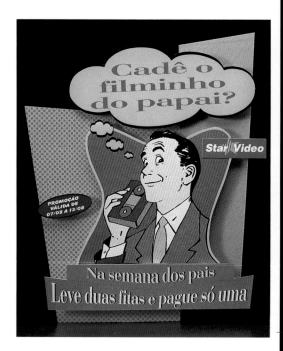

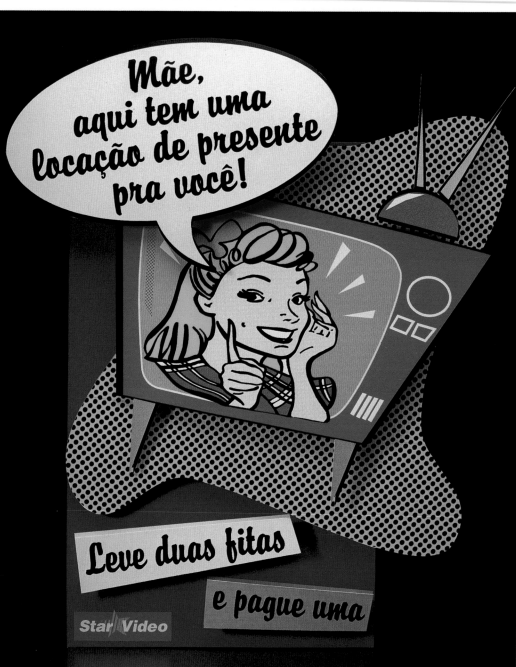

Promotional Poster
Design Firm **Animus**
Comunicaçáo
Art Director **Rique Nitzsche**
Designer **Felicío Torres**
Client **Texaco Brasil**
Software **CorelDraw 4**
Hardware **PC 486**

Audio Store Promotional Poster
Design Firm **Animus**
Comunicaçáo
Art Director **Rique Nitzsche**
Designer **Felicío Torres**
Client **Texaco Brasil**
Software **CorelDraw 4**
Hardware **PC 486**

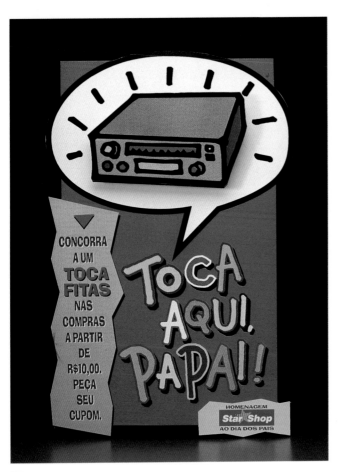

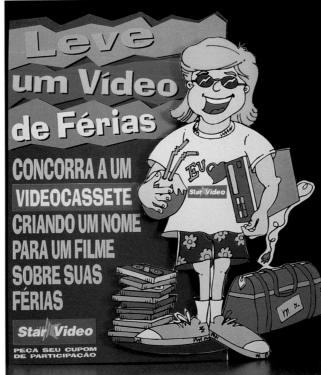

Video Store Promotional Poster
Design Firm **Animus**
Comunicaçáo
Art Director **Rique Nitzsche**
Designer **Felicío Torres**
Client **Texaco Brasil**
Software **CorelDraw 4**
Hardware **PC 486**

Audio Store Promotional Poster
Design Firm **Animus**
Comunicaçáo
Art Director **Rique Nitzsche**
Designer **Felicío Torres**
Client **Texaco Brasil**
Software **CorelDraw 4**
Hardware **PC 486**

28

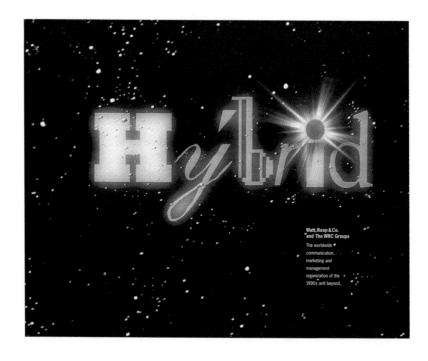

So how did such a nice group of people from Cleveland get to be so tough?

Ladies and gentlemen, Watt, Roop & Co. is located on the planet Earth in the south-ern extremity of the Milky Way.

It started life at the beginning of 1981 in Cleveland, Ohio, where at the time everything was pretty rotten. But WRC persevered, as did Cleveland, and today both are at the vanguard of their respective life paths.

Watt, Roop & Co. began as a public relations firm, strongly emphasizing marketing, investor relations, corporate communication and design. It grew rapidly over its first five years and became the first PR firm ever to make Inc. Magazine's list of the 500 most rapidly growing privately held companies (WRC came through the gate 99th overall).

Today, pound for pound, as they used to say about the great prizefighter Sugar Ray Robinson, we are a lean, mean fighting machine that gives our clients a lot of sock for their money.

We don't have a string of branch offices all over hell's half acre. We have one powerhouse office that truly can do it all for our world class clients. Yes, we have affiliates (43) across the U.S. and the globe, but not as overhead-laden appendages that drain our energy or our resources or add to your costs. You only pay for what you use.

Now look on the next few pages and we'll tell you more about Watt, Roop & Co. and the multifaceted groups within its organization: WRC Marketing & Advertising, WRC Design, WRC Publishing, WRC Training, WRC Entertainment and WRC/Howell Sponsorship & Event Marketing.

Promotional Brochure
Design Firm **Watt, Roop & Co.**
All Design **S. Jeffrey Prugh**
Photographers **George Anderson, Chris Lynch**
Client **Self-promotion**
Software **Aldus PageMaker 5.0, Adobe Photoshop 2.5.1**
Hardware **Macintosh Quadra 650**

The photographs were scanned and manipulated in Photoshop. Low-resolution copies were placed in PageMaker for position only, to be replaced with high-resolution versions by the printer.

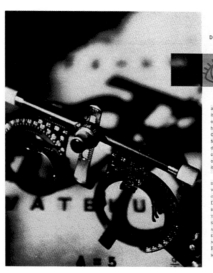

WRC **Design Group**

Watt, Roop & Co. has always believed in having its own in-house design operation. And we always have. Today, WRC Design Group is one of the finest computerized design studios in the country, working for our organization's units and its own clientele as well.

OUR 10-MEMBER DESIGN STAFF HAS GROWN WITH THE ORGANIZATION OVER THE YEARS. WRC DESIGN'S DIRECTOR HAS BEEN WITH US FOR MORE THAN 10 YEARS AND HIS SENIOR DESIGNERS ARE ALSO LONG-TIME STAFF-ERS. WHAT DOES THIS MEAN? STABILITY. EXPERIENCE WITH ALL SORTS OF CLIENTS.

Plus, we have all the technology. We were one of the first studios in the country to go to the Macintosh system. Each of our designers has his or her own Mac, updated constantly with the latest software. That means savings to you and to us. That also means high quality, quickly produced work.

International award-winning WRC Design Group provides high quality corporate graphics, annual reports, internal and external publications, print and broadcast advertising graphics, video and film production, marketing collateral and all sorts of promotional marketing materials.

If it can be designed, we can do it.

WRC **Publishing Group**

This is our specialty publishing operation. It branched naturally from the spate of publishing work we were already doing for our clients.

Our first specialty venture occurred seven years ago when our client, the Steel Service Center Institute, asked us if we'd be interested in publishing the daily magazine for its international convention. We took the assignment and that was the beginning of WRC Publishing Group.

In addition to magazines, this group publishes business directories, guides and other print materials where the clients wish us to do total turn-key work. That means we sell the advertising, prepare

and edit copy, design, produce and distribute the published piece. In some cases, specialty publishing situations are funded entirely by advertisers, while in others, clients will provide some financial support.

Each situation is different. And we're flexible to custom-tailoring to our clients' specific needs.

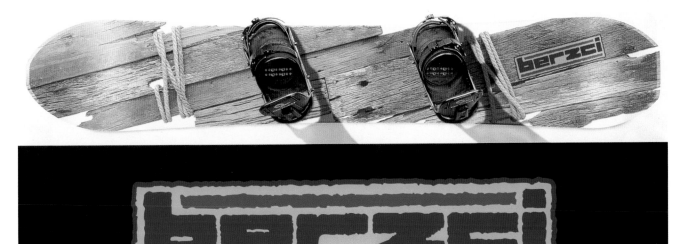

Promotional Design Portfolio
Design Firm **Elton Ward**
Design
Art Director **Steve Coleman**
Designer **Simon Macrae**
Client **Self-promotion**
Software **Adobe Illustrator**
5.5, Adobe Photoshop
Hardware **Macintosh Quadra**
950

Press Kit
Design Firm **Tracy Sabin**
Graphic Design
Art Director **Alison Hill**
Designer/Illustrator **Tracy**
Sabin
Client **Turner Broadcasting**
Software **Soft-Logik**
PageStream
Hardware **Amiga 2000**

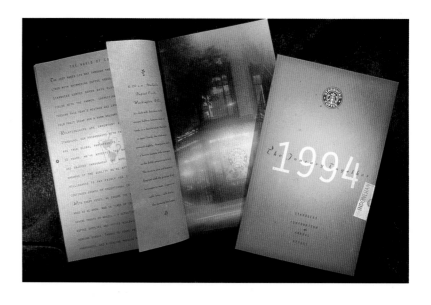

30 **Promotional Calendar**

Design Firm **Hornall Anderson Design Works**

Art Director **Jack Anderson**

Designers **Jack Anderson, Mary Hermes, Julie Keenan**

Client **Food Services of America**

Software **QuarkXPress, Adobe Photoshop**

Hardware **Power Macintosh 8100 72/1000**

Rich photo-montages highlight the company's products and make each one the visual focus of the page. A flowing calligraphic style, soft color palette, and high quality paper stock contribute to the overall sophisticated, professional image of the piece and add to its appeal.

Annual Report

Design Firm **Hornall Anderson Design Works**

Art Director **Jack Anderson**

Designers **Jack Anderson, Julie Lock, Mary Chin Hutchinson**

Client **Starbucks Coffee Company**

Software **QuarkXPress, Adobe Photoshop**

Hardware **Power Macintosh 8100, 72/1000**

The type, materials, color palette, illustration, and photographic style combine to project a warmer, friendlier image than most annual reports. Recycled stock was used, as well as print with soy-based inks.

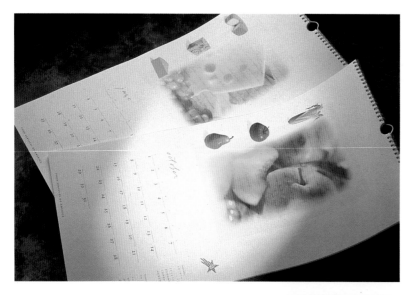

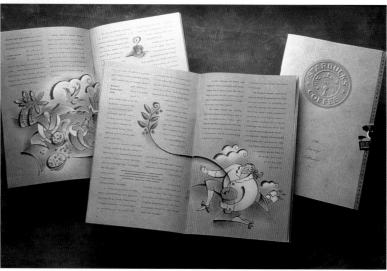

Annual Report

Design Firm **Hornall Anderson Design Works**

Art Director **Jack Anderson**

Designers **Jack Anderson, Julie Lock, Bruce Branson-Meyer, Mary Chin Hutchinson**

Client **Starbucks Coffee Company**

Software **QuarkXPress**

Hardware **Power Macintosh 8100 72/1000**

More color was added to Starbucks' annual report to reflect the company's lively personality. Designers used recycled and recyclable stock, and printed with soy-based inks.

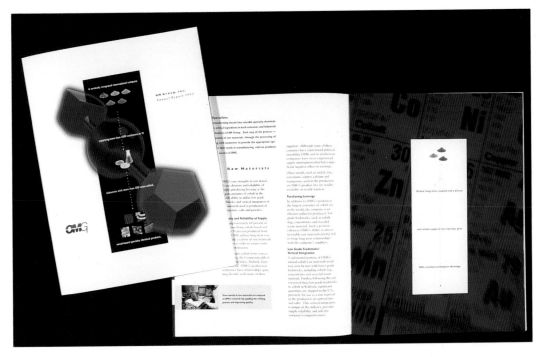

Annual Report
Design Firm **Watt, Roop & Co.**
All Design **S. Jeffrey Prugh**
Photographers **Roger Mastroianni, Karen Ollis, Don Snyder**
Client **OM Group, Inc.**
Software **Aldus PageMaker 5.0, Adobe Photoshop 2.3.1**
Hardware **Macintosh Quadra 650**

The illustration and photo-manipulations were all done in Photoshop, then exported into PageMaker. Low-resolution copies were used for position only and then replaced with high-resolution versions by the printer.

Promotional Poster
Design Firm **Watt, Roop & Co.**
Art Director **Gregory Oznowich**
Designers **Gregory Oznowich, Kurt R. Roscoe**
Client **The American Institute of Graphic Arts, Cleveland Chapter**
Software **Aldus PageMaker 5.0, Adobe Photoshop 2.5.1**
Hardware **Macintosh Quadra 950**

The original photographs were outlined and retouched by the photographer. The designers manipulated and placed the images with PageMaker and Photoshop.

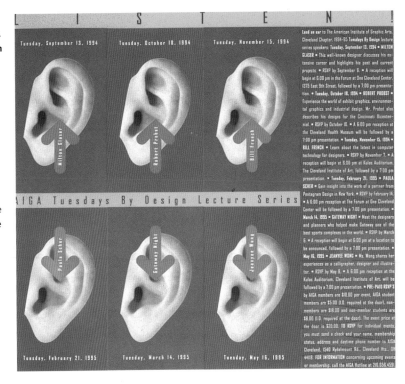

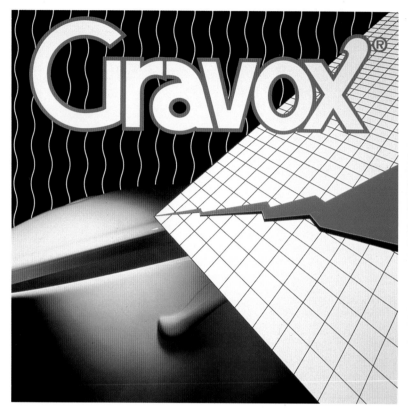

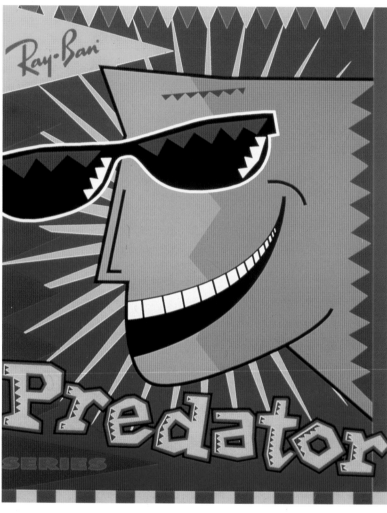

Trade Presentation Brochure
Design Firm **Elton Ward**
Design
Art Director **Steve Coleman**
Designer **Andrew Schipp**
Client **Cerebos Australia**
Software **Adobe Illustrator 5.5**
Hardware **Macintosh Quadra**
950

Simple colors and graphics
were created in Illustrator to
reflect the gravy company's
strong brand name.

T-Shirt
Design Firm **Elton Ward**
Design
Art Director **Steve Coleman**
Designer **Jason Dominiak**
Client **Ray-Ban Australia**
Software **Adobe Illustrator 5.5**
Hardware **Macintosh Quadra**
950

The contemporary T-shirt
design was created in
Illustrator. A "punk" filter tool
was applied to the logo signa-
ture to complement the rest of
the layout.

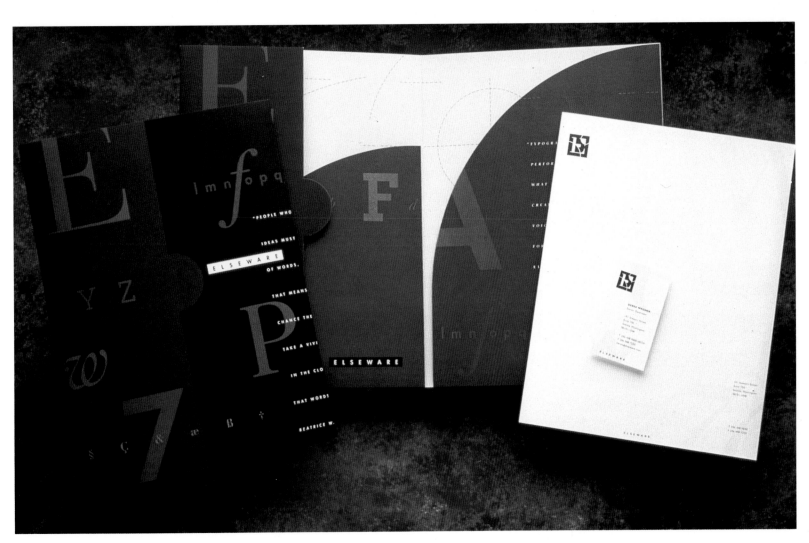

Corporate Folder
Design Firm **Hornall Anderson
Design Works**
Art Director **Jack Anderson**
Designers **Jack Anderson,
Debra Hampton, Leo
Raymundo**
Client **ElseWare Corporation**
Software **Aldus FreeHand**
Hardware **Power Macintosh
8100, 72/1000**

The ElseWare folder design is
made up of various quotes
and fonts created in FreeHand
to illustrate the product.

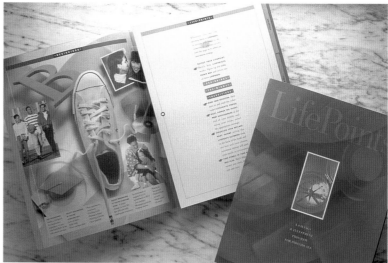
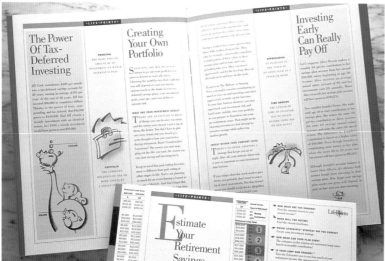
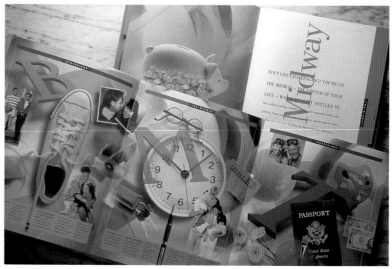

Financial Planning Brochure
Design Firm **Hornall Anderson Design Works**
Art Director **Jack Anderson**
Designers **Jack Anderson, Lisa Cerveny, Suzanne Haddon**
Client **The Frank Russell Company**
Software **QuarkXPress, Adobe Photoshop, Aldus FreeHand**
Hardware **Power Macintosh 8100 72/1000**

Photo montages were used to illustrate the difference between
the three phases offered in the Life-Points plan—Beginnings,
Midway, and Transition. Large type treatments, warm illustra-
tions, and colorful headlines alleviate user confusion, and pro-
vide user-friendly steps for determining retirement strategies.

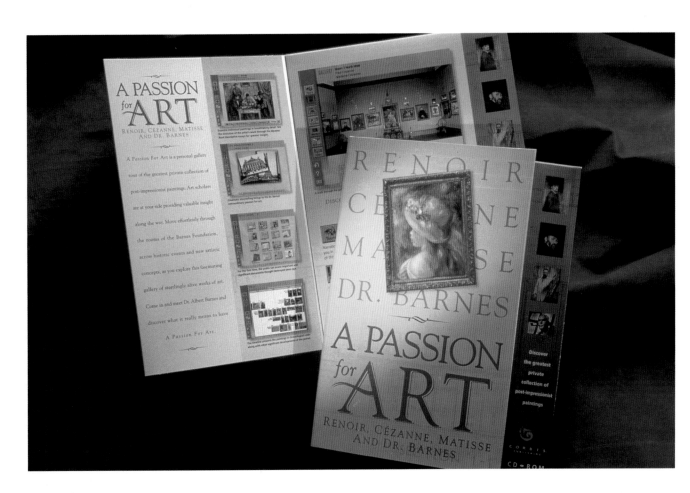

Art Brochure
Design Firm **Hornall Anderson**
Design Works
Art Director **Jack Anderson**
Designers **Jack Anderson, John**
Anicker, David Bates
Client **Corbis Barnes**
Software **Aldus FreeHand,**
Adobe Photoshop
Hardware **Power Macintosh**
72/1000

This design illustrates exam-
ples of the various art pieces
in the company's archive. The
background is a subtle illustra-
tion of archival architectural
diagrams, adding to the over-
all antique look of the piece.

Annual Report
Design Firm **Hornall Anderson Design Works**
Art Director **Jack Anderson**
Designers **Jack Anderson, Mary Hermes, Julie Keenan**
Client **Services Group of America**
Software **Aldus PageMaker**
Hardware **Power Macintosh 8100 72/1000**

Large type, flowing copy, vivid colors, and expressive photography create magazine-like layouts that appeal to the reader. Each spread highlights one of the SGA companies with a major photo and minor illustrations.

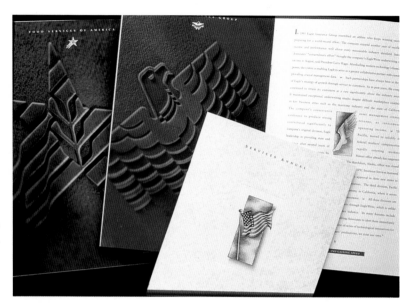

Annual Report
Design Firm **Hornall Anderson Design Works**
Art Director **John Hornall**
Designers **John Hornall, Mary Hermes, Leo Raymundo, Mary Chin Hutchinson**
Client **Advanced Technology Laboratories**
Software **QuarkXPress**
Hardware **Power Macintosh 8100 72/1000**

Photo-montages were used to illustrate the world renowned medical facilities located on four continents. News articles merged with the countries' maps pin-pointed the highlighted cities.

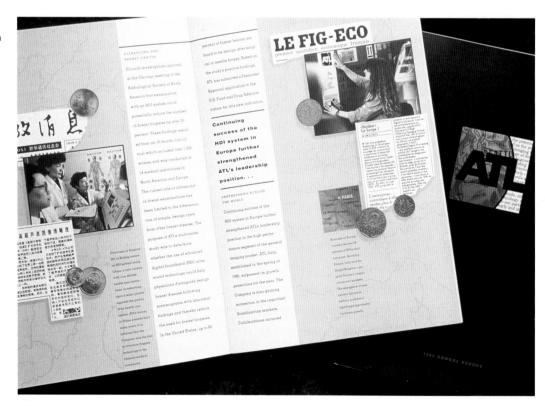

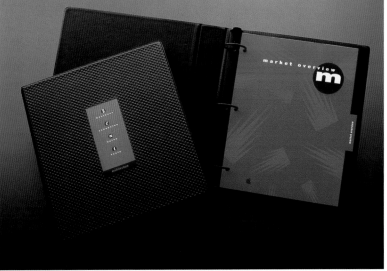

Three-Ring Binder
Design Firm **Rapp Collins**
Communications
All Design **Bruce Edwards**
Client **Apple Computer**
Software **Adobe Illustrator**
Hardware **Macintosh FX**

Illustrator software program
allowed for easy manipulation,
expansion, and stretching of
type.

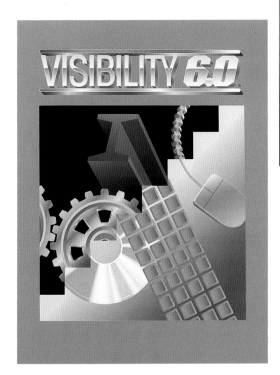

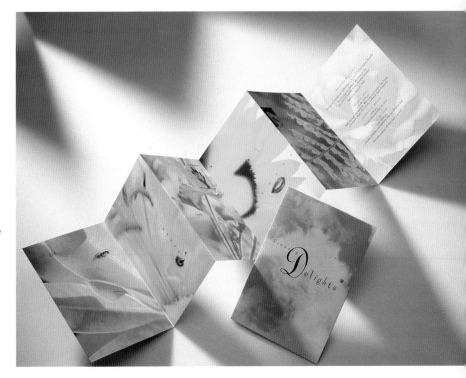

Folder/Binder Cover
Design Firm **James Potocki**
Communications
All Design **James Potocki**
Client **Visibility**
Software **Adobe Illustrator,**
Adobe Photoshop
Hardware **Macintosh**

Original design was conceived
with markers, and the mechan-
ical artwork was then accom-
plished with computer soft-
ware.

Fund-Raiser Invitation
Design Firm **Rapp Collins**
Communications
All Design **Bruce Edwards**
Client **Minnesota Landscape**
Arboretum
Software **QuarkXPress, Adobe**
Illustrator
Hardware **Macintosh Centris**
650

Page layout and typography
were developed in
QuarkXPress and the cover
typography was created in
Illustrator.

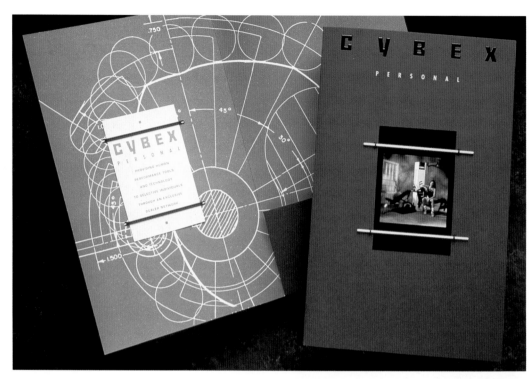

Promotional Folder, Brochure, Poster
Design Firm **Hornall Anderson Design Works**
Art Director **Jack Anderson**
Designers **Jack Anderson, David Bates, Jeff McClard, Julie Keenan**
Client **Cybex**
Software **Aldus FreeHand**
Hardware **Power Macintosh 8100 72/1000**

The black and white photo of a body builder was Xeroxed onto a vellum-finish uncoated paper and hand-tinted with pastels. It was merged with technical line-work and high-contrast black and white photographs of the actual product. The line-work, type, and product shots were printed in a metallic split fountain over the 4-color image.

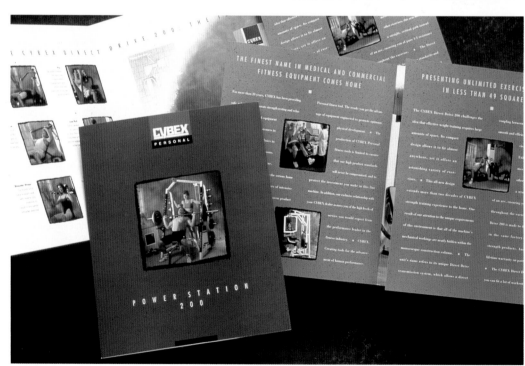

Solving the Quintic

with Mathematica

Computer Software Poster
Design Firm **Wolfram Research Publications Department**
Art Director **John Bonadies**
Designer **Jennifer Lofgren**
Client **Wolfram Research, Inc.**
Software **Mathematica, QuarkXPress, Adobe Illustrator, Adobe Photoshop**
Hardware **Macintosh Quadra 950**

Graphics and the mathematical equation typeset were created in Mathematica. Layout was completed in QuarkXPress and the final image was printed with a combination of 6-color, metallic, and black and metallic mix.

HOT on THE CHASE

Margo is setting design on fire

BY MARGO BOWLES

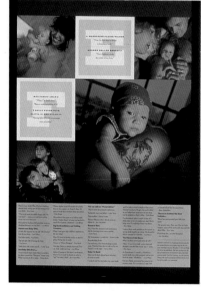

Magazine

Design Firm **Peterson & Company**

Art Directors **Jan Wilson**

Designers **B. Peterson, J. Wilson, S. Ray, N.T. Pham, D. Eliason**

Client **Dallas Society of Visual Communications**

Software **QuarkXPress 3.3, Photoshop 3.1,**

Hardware **Power Macintosh 7100**

The masthead for this design was a tip-on, and the entire image was printed with metallic inks.

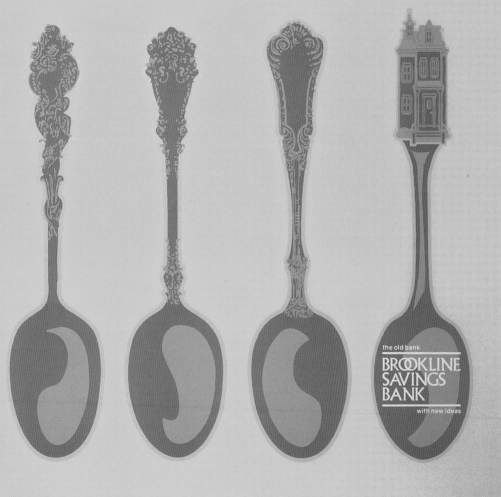

Poster
Design Firm **760 Associates**
Art Director **Beth Santos**
Design
Designer **Beth Santos**
Client **Brookline Savings Bank**
Software **Aldus FreeHand**
Hardware **Macintosh Quadra**
650

Hey, Phil...Read This:

THE JUMBO-TYPE, CLIENT-FRIENDLY TABLE OF CONTENTS

One For The Books....... 3 (It's right over there ☞)

Fresh/Refresh....... 6

Dutch Treat....... 8

Fresh Face....... 14

Profile/Brush With Fame....... 15

Promoting Your Business....... 16

Roughage....... 16

Calendar Of Events....... 18

A BIG WELCOME TO THESE NEW MEMBERS

Matt Davis, Pierce, DeSilva & Galyean Advertising
Ann Ferguson, Nobel Insurance Group
Gregg A. Floyd, Gsf Advertising Design
Bill Galyean, Pierce, DeSilva & Galyean Advertising
Keith Graves, Melting Helmet Studio
Edwin Hall, Bob Bond & Others
Jennifer Ruoho, Ruoho & Assoc.
Alf Launetar, Pierce, DeSilva & Galyean Advertising
Randy Martin, McClan Erickson
Sally Matthews, Pierce, DeSilva & Galyean Advertising
John Xiang, Join Weng Photography

EDITORIAL BOILERPLATE COPY

Rough is a quasi-monthly publication produced pro bono in its entirety by, for and about the members, associates and friends of the DSVC. The articles, opinions, language and insults are not always intentional and are not necessarily those of the DSVC membership at large, the Board or the current staff of ROUGH. Thanks for your continued support and comments, positive or negative. Letters to the Editor, story ideas and information for Roughage can be faxed to Phil Hollenbeck at (214) 421-3736. (Please submit no later than the 5th of the month for inclusion in the following month's issue of ROUGH.)

AD SIZES AND PRICES:

1/2 col...	(3-3/4" x 4-7/8")	$125.00
1 col...	(3-3/4" x 4-7/8")	$250.00
2 col...	(8-1/2" x 9-3/4")	$450.00
Full page, non-bleed......		$850.00

DEADLINE:

Camera-ready art and payment-in-full due no later than the 5th of the month. Ad will appear in the following month's issue of ROUGH. Send art and payment to Rough, c/o Margie Bowles, 4201 Shorecrest Drive, Dallas, Texas 75209.

EDITOR & CHIEF WHIPPING POST
Phil "The Blame Stops Here" Hollenbeck

ASSOCIATE EDITOR
Margie Bowles

ART DIRECTION AND DESIGN
Peterson & Company

SPECIAL SUPPLIERS
S.D. Warren, JTM Colorscan, Inc., Hughes Printing

FRESH/REFRESH PHOTOGRAPHER
Dick Patrick

FRESH FACE PHOTOGRAPHER
Doug Davis (student member)

FRESH FACE WRITER
Joy Lohmann (student member)

ADVERTISING SALES
Margie Bowles

FOR MEMBERSHIP INFORMATION
contact Sue Reynolds at

(214) 241-2017

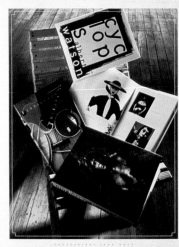

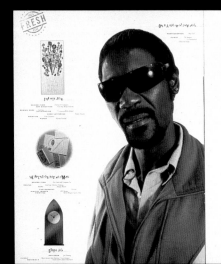

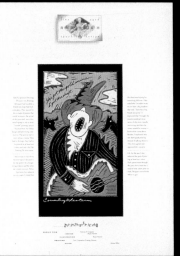

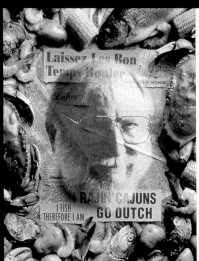

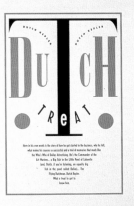

Designers **B. Peterson, J. Wilson, D. Eliason, N.T. Pham, S. Ray**

Client **Dallas Society of Visual Communications**

Software **QuarkXPress, Adobe Photoshop**

Hardware **Macintosh 7100**

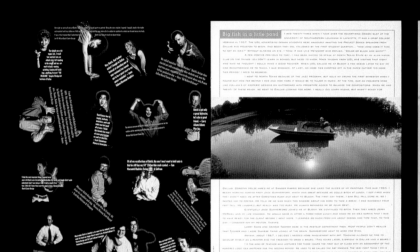

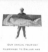

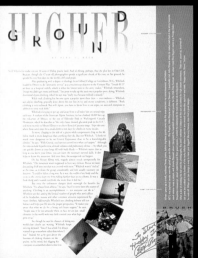

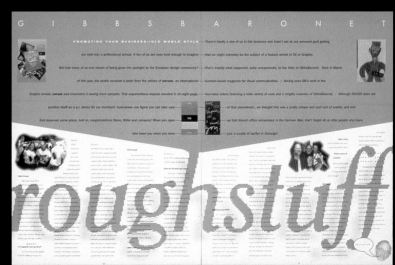

CORPORAT

IDENTITY

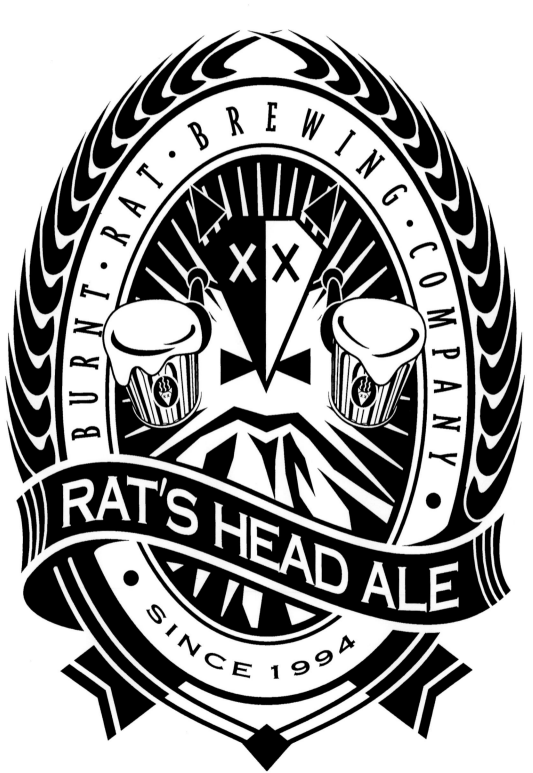

Brewery
Design Firm **Price Learman**
Associates
All Design **Ross West**
Client **Burnt Rat Brewing**
Software **Aldus FreeHand 4.0**
Hardware **Macintosh Quadra**
650

This logo was created entirely
in Aldus FreeHand 4.0 using a
number of tools and methods.

46

Logo
Design Firm **Price Learman Associates**
All Design **Ross West**
Client **Bush Pushers Rescue**
Software **Aldus FreeHand 4.0, Adobe Photoshop, Adobe Streamline**
Hardware **Macintosh Quadra 650**

This logo began as a hand-drawn image. The image was then scanned on a flatbed scanner and saved as a TIFF. The image was then opened in Adobe Streamline 3.0, manipulated, outlined, and saved as an Aldus FreeHand file. To add copy and borders, the designer manipulated the image in FreeHand 4.0, and to achieve the "stamp" look, a combination of tools and effects in Adobe Photoshop were used.

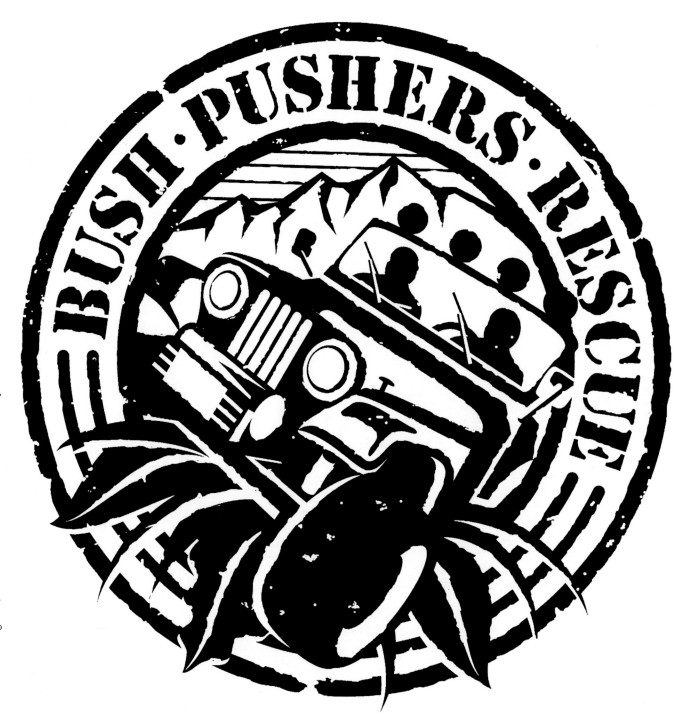

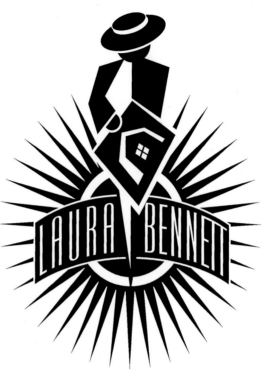

Logo
Design Firm **Price Learman Associates**
All Design **Ross West**
Client **Laura Bennett**
Software **Aldus FreeHand 4.0**
Hardware **Macintosh Quadra 650**

This logo was created entirely in Aldus FreeHand 4.0 using a number of tools and methods,

Museum
Design Firm **Price Learman Associates**
All Design **Ross West**
Client **Frye Art Museum**
Software **Aldus FreeHand 4.0**
Hardware **Macintosh Quadra 650**

This logo was created entirely in Aldus FreeHand 4.0 using a number of tools and methods.

Logo
Design Firm **Price Learman Associates**
All Design **Ross West**
Client **Self-promotion**
Software **Aldus FreeHand 4.0, Adobe Photoshop**
Hardware **Macintosh Quadra 650**

The majority of this identity was created using Aldus FreeHand 4.0. The background pattern was achieved by printing a solid black laser print, crumpling the paper to achieve the pattern, photocopying the image, and ultimately scanning the pattern on a flatbed scanner. The scanned image was placed into FreeHand, made transparent, manipulated, and assigned a color. The "paste inside" option was used throughout this design. The three-dimensional portion of the logo was created in Photoshop, as were the "cloud" images.

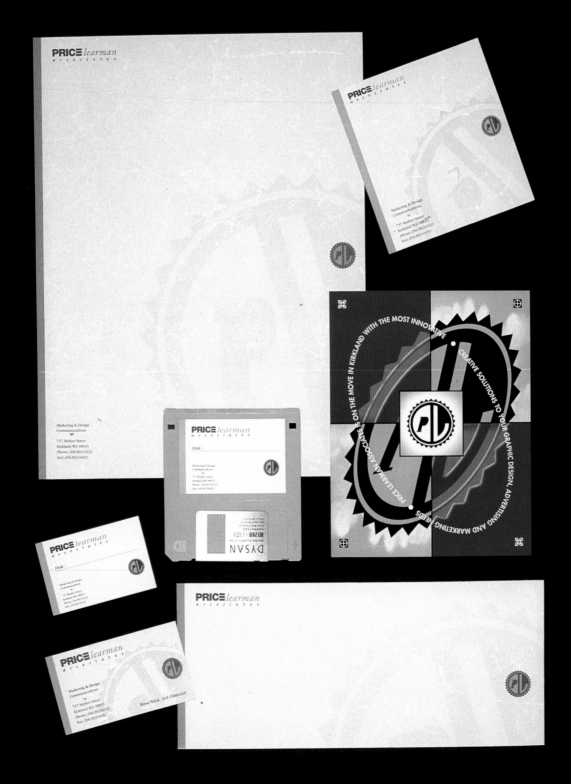

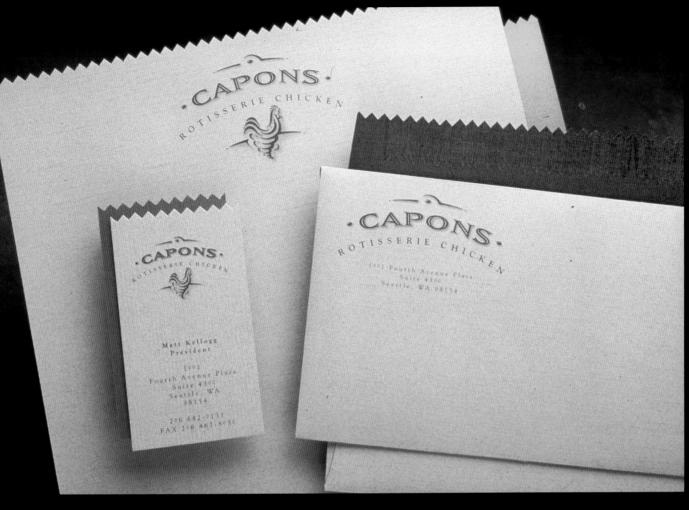

Stationery
Design Firm **Hornall Anderson Design Works**
Art Director **Jack Anderson**
Designers **Jack Anderson, David Bates**
Client **Capons Rotisserie Chicken Restaurant**
Software **Aldus FreeHand**
Hardware **Power Macintosh 8100 72/1000**

For this project, a spinning tornado was designed into a chicken's body to depict a "quick, take-out" mentality. The zig-zag, tear-like edge of the stationery program communicates the idea of "take-out" bags. Colors on the back of the stationery were warm and full-blended.

Logo
Design Firm **Price Learman Associates**
All Design **Ross West**
Client **Kathy Magner**
Software **Aldus FreeHand 4.0**
Hardware **Macintosh Quadra 650**

This identity program was corrected entirely with Aldus FreeHand 4.0. All graphics and typography were created and manipulated using various FreeHand tools. All films for final production were produced digitally.

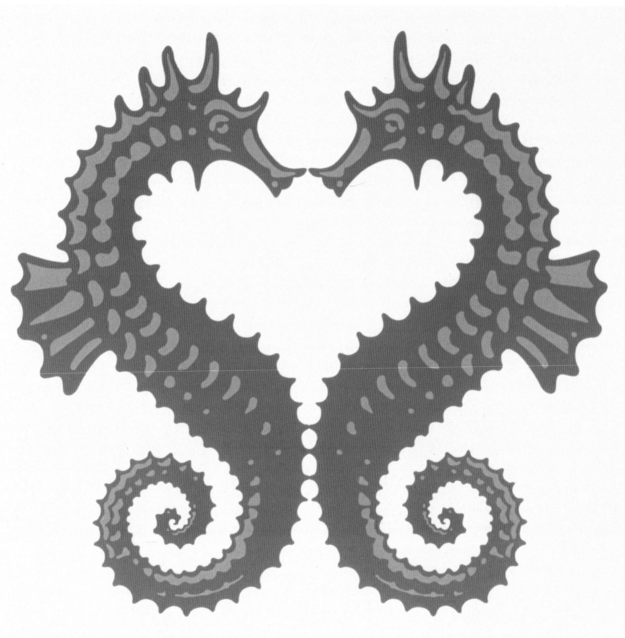

Promotional Logo
Design Firm **Mires Design**
Art Director **Scott Mires**
Designer **Tracy Sabin**
Client **The Master's Group**
Software **Adobe Illustrator 5.5**
Hardware **Macintosh 8100**

With the use of a drawing pro-
gram and hand-drawn art, the
designer created this logo for
a promotional trip for cardiolo-
gists to Hawaii.

Product Logo
Design Firm **Mires Design**
Art Director **José Serrano**
Designer **Tracy Sabin**
Client **Cranford Street**
Software **Adobe Illustrator 5.5**
Hardware **Macintosh 8100**

52

GOLDLINE

Corporate Logo
Design Firm **Mires Design**
Art Director **José Serrano**
Designer **Tracy Sabin**
Client **Goldline**
Software **Art Expression**
Hardware **Amiga 2000**

This rejected comp for a housing insulation company was created entirely on the computer with the use of a vector-based drawing program.

Corporate Logo
Design Firm **Tracy Sabin Graphic Design**
Art Director **Tracy Sabin**
Designer **Tracy Sabin**
Client **Self-promotion**
Software **Art Expression**
Hardware **Amiga 2000**

This logo for a graphic design firm was created from original art that was scanned into the computer and altered in Art Expression.

Record Label Logo
Design Firm **Tracy Sabin**
Graphic Design
Art Director **Eero Sabin**
Designer **Tracy Sabin**
Client **Big Weenie Records**
Software **Art Expression**
Hardware **Amiga 2000**

Corporate Logo
Design Firm **Franklin Stoorza**
Art Director **Craig Fuller**
Designer **Tracy Sabin**
Client **San Diego Gas & Electric**
Software **Art Expression**
Hardware **Amiga 2000**

The logo, used by a division of the company known as Team Coyote because they work outside the bureaucracy to solve urgent problems, began as an original illustration that was cut in amber and manipulated in Art Expression.

Opera Logo
Design Firm **Franklin Stoorza**
Art Director **Kelly Davenport**
Designer **Tracy Sabin**
Client **San Diego Opera**
Software **Art Expression**
Hardware **Amiga 2000**

This logo, for the opera "Eugene Oniegan," was created with a combination of original, hand-drawn art and computer-generated effects.

54

Apron Company Logo
Design Firm **Tracy Sabin**
Graphic Design
Art Director **Tracy Grillo**
Designer **Tracy Sabin**
Client **Heritage Apron Co.**
Software **Art Expression**
Hardware **Amiga 2000**

TURNER ENTERTAINMENT CO

Brochure Logo, Cover
Design Firm **Tracy Sabin**
Graphic Design
Art Director **Alison Hill**
Designer/Illustrator **Tracy Sabin**
Client **Turner Entertainment Company**
Software **Art Expression**
Hardware **Amiga 2000**

This design is from a logo and rejected cover of a brochure outlining the film collections of Turner Entertainment Company. An important aspect of the company is the storage and restoration of sensitive film materials, hence the atlas image. The logo was created from a hand-drawn sketch and the cover was generated entirely on the computer.

56

Cafe

Design Firm **Monroy & Cover Design**

All Design **Fernando Monroy, Gail Cover**

Client **Sun Microsystems (Sun Star Events)**

Software **Adobe Photoshop, Adobe Illustrator**

Hardware **Power Macintosh 6100/60 AV**

Designers created a blend and added noise to background images in Photoshop. The file was then placed into Illustrator, where type was added.

SunStar
Events

Logo
Design Firm **Price Learman Associates**
All Design **Ross West**
Client **Angry Youth**
Software **Aldus FreeHand 4.0, Adobe Streamline 3.0**
Hardware **Macintosh Quadra 650**

For this design, a black and white photo was scanned on a flatbed scanner and saved as a TIFF. The file was then opened in Adobe Streamline, manipulated, outlined, and saved as an Aldus FreeHand file. The image was then opened in FreeHand to add copy, bullet holes, and final revisions.

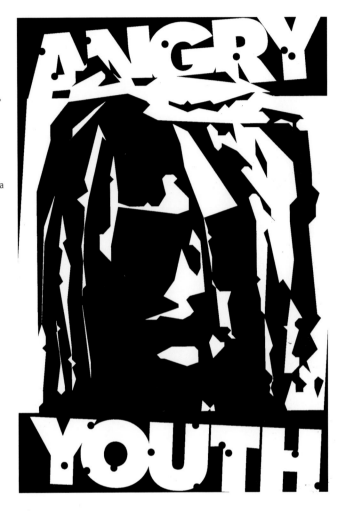

Logo
Design Firm **Monroy & Cover Design**
All Design **Fernando Monroy**
Client **Cakes 'N Places**
Software **Adobe Illustrator 5.5**
Hardware **Power Macintosh 6100/60 AV**

This geometric logo was created by duplicating on the computer a simple design and uses both Opti-Raleigh and Garamond Italic fonts.

58

Company Logo
Design Firm **Monroy & Cover Design**
All Design **Gail Cover**
Client **Inquire "Just Ask"**
Software **Adobe Illustrator 5.5**
Hardware **Power Macintosh 6100/60 AV**

This logo for a market research company was created entirely in Illustrator.

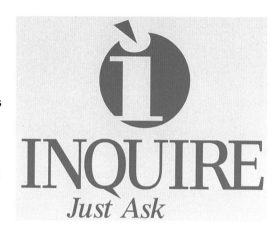

Company Logo
Design Firm **Monroy & Cover Design**
All Design **Gail Cover**
Client **Amanda Pirot Marketing**
Software **Adobe Illustrator 5.5**
Hardware **Power Macintosh 6100/60 AV**

Company Logo
Design Firm **Monroy & Cover Design**
Art Director **John Leonard**
Designer **Fernando Monroy**
Client **Marin Outdoors**
Software **Adobe Photoshop, Adobe Illustrator, KPT Bryce**
Hardware **Power Macintosh 7100**

The original image was sketched, scanned in, and brought into Illustrator. The blends for this project were created in Photoshop using KPT Bryce filters to avoid banding in the printing process. The typeface used is a stylized Futura.

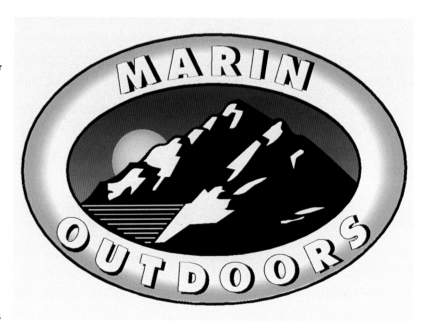

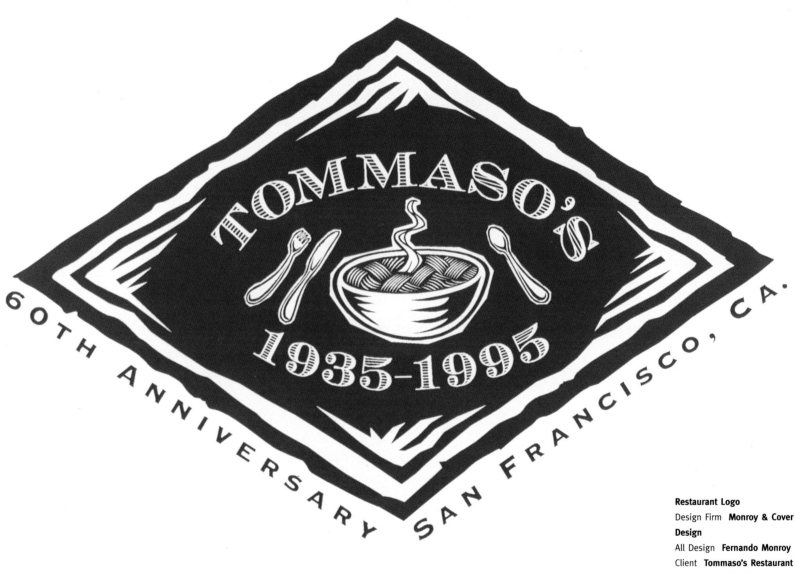

Restaurant Logo
Design Firm **Monroy & Cover Design**
All Design **Fernando Monroy**
Client **Tommaso's Restaurant**
Software **Adobe Illustrator**
Hardware **Power Macintosh 6100/60 AV**

The scanned image for this design was brought into Illustrator where it was re-traced. The border was given a rough look with the use of the "distort roughen" filter. The typefaces on this logo are Copperplate and Recorial.

60

Sales Conference Logos
Design Firm **Hornall Anderson Design Works**
Art Director **Jack Anderson**
Designers **Jack Anderson, Cliff Chung, Scott Eggers, David Bates, Leo Raymundo**
Client **Food Services of America**
Software **Aldus FreeHand**
Hardware **Power Macintosh 8100 72/1000**

The star in this design created in FreeHand is a direct reference to the FSA logo and is made up of loose "energy bursts".

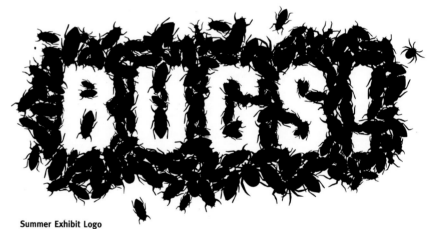

Summer Exhibit Logo
Design Firm **Rapp Collins Communications**
All Design **Bruce Edwards**
Client **Minnesota Zoo**
Software **Adobe Illustrator**
Hardware **Macintosh FX**

This design began as rough sketches that were then combined with five bug images created in Illustrator. The designer spent forty hours reducing, enlarging, and placing bugs until the proportions were correct.

Tree Care Company Logo
Design Firm **Watt, Roop & Co.**
All Design **Gregory Oznowich**
Client **Morningstar Tree Service, Inc.**
Software **Aldus FreeHand 3.1**
Hardware **Macintosh Quadra 950**

The logo was designed in FreeHand 3.1, then exported and saved as both TIFF and EPS files for applications on letterhead, trucks, and forms.

Environmental Consulting Firm Logo
Design Firm **Hornall Anderson Design Works**
Art Director **Jack Anderson**
Designers **Jack Anderson, Julie Lock, Lian Ng**
Client **Shapiro & Associates, Inc.**
Software **Aldus FreeHand**
Hardware **Power Macintosh 8100 72/1000**

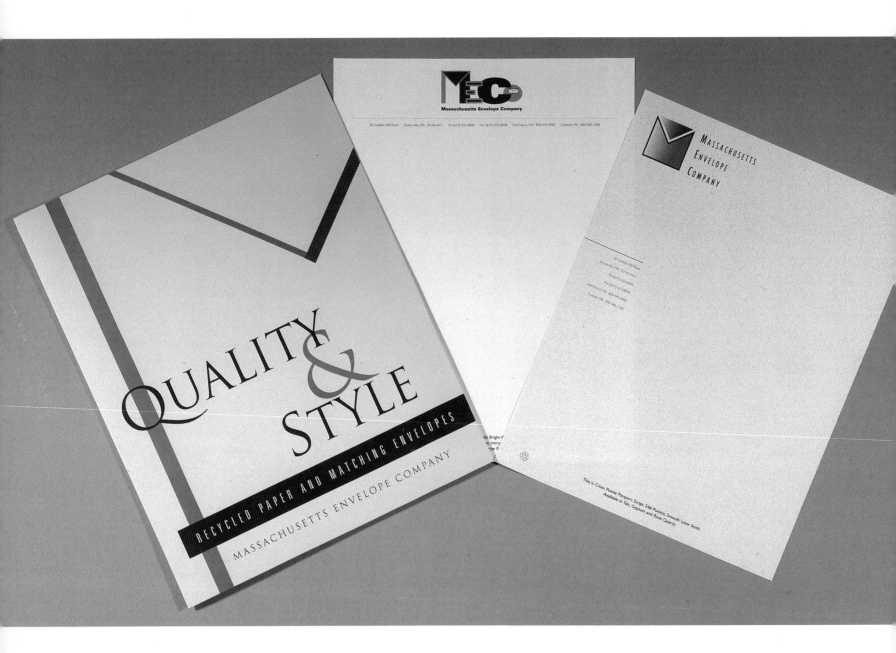

Recycled Stationery Pocket Folder
Design Firm **760 Associates**
Art Director **Beth Santos**
Design
Designer **Beth Santos**
Client **Massachusetts Envelope Company**
Software **Adobe Illustrator, QuarkXPress**
Hardware **Macintosh Quadra**
650

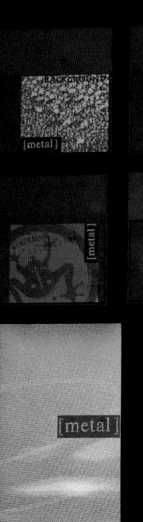

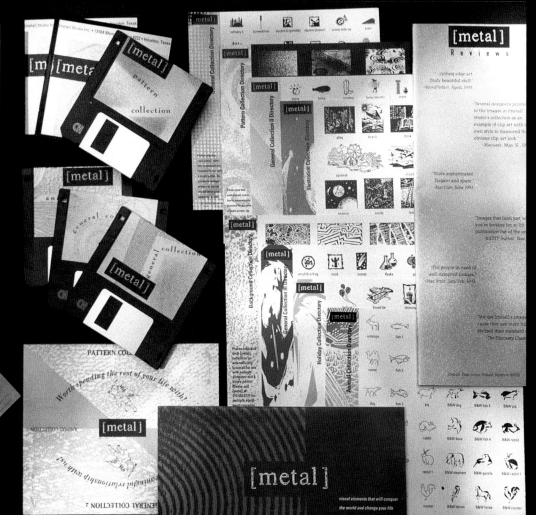

**Product Identity, Marketing
Brochures**
Design Firm **Peat Jariya
Design, Metal Studio**
Art Director **Peat Jariya**
Designer **Peat Jariya, Metal
Design Team**
Client **Metal Studio**
Software **Aldus PageMaker,
Adobe Illustrator**
Hardware **Macintosh Centris**

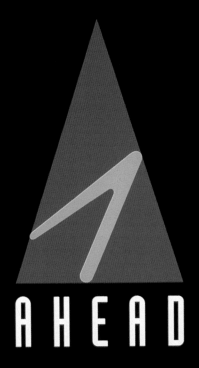

Logo
Design Firm **Clifford Selbert**
Design Collaborative
Art Directors **Robin Perkins,**
Clifford Selbert
Designers **Robin Perkins, Jeff**
Breidenbach
Client **Ahead, Inc.**
Software **Aldus FreeHand**
Hardware **Macintosh Quadra**
840 AV

These logos were created with
a common design element —
the letter"V"—and with a flex-
ible design adaptable to
future products.

Virtual Music Logo
Design Firm **Clifford Selbert**
Design Collaborative
Art Directors **Robin Perkins,**
Clifford Selbert
Designers **Robin Perkins, Jeff**
Breiderbach
Client **Ahead, Inc.**
Software **Aldus FreeHand**
Hardware **Macintosh Quadra**
840A

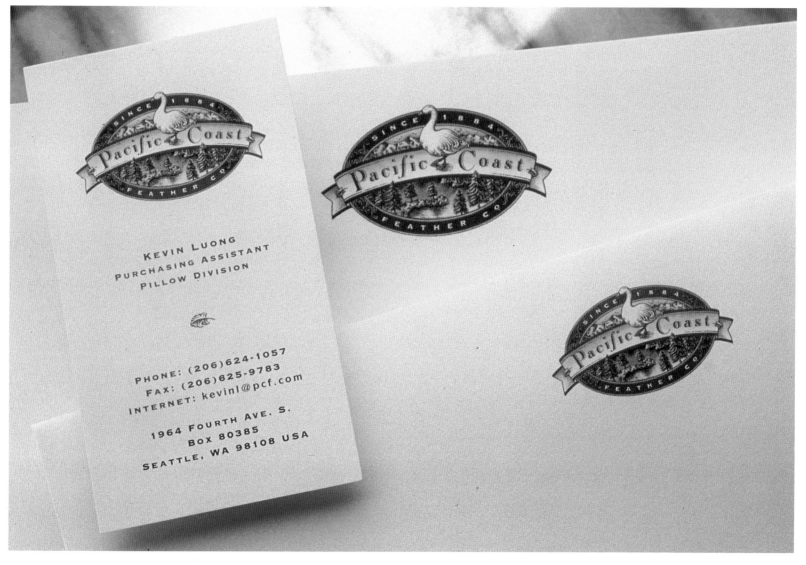

Stationery
Design Firm **Hornall Anderson Design Works**
Art Director **Jack Anderson**
Designers **Jack Anderson, Julie Lock, Heidi Favour, Leo Raymundo**
Client **Pacific Coast Feather Company**
Software **Aldus FreeHand, Adobe Photoshop**
Hardware **Power Macintosh 8100 72/1000**

The Pacific Coast Feather Company, a premier manufacturer of pillows and down comforters, chose to introduce a new, warmer appearance that set the product identity apart from its competitors. The design firm emphasized the company's long-time establishment in the northwest through warm color palette illustration of mountains, trees, and water. The goose and oval outline were retained from the previous logo design.

ART

Dreaming of Horses
Design Firm **Imagewright**
All Design **Annie Higbee**
Client **Self-promotion**
Software **Fractal Design
Painter, Adobe Photoshop**
Hardware **Macintosh**

The designer cloned images of
horses to create a team and
collaged pieces together using
Painter's cloning methods.

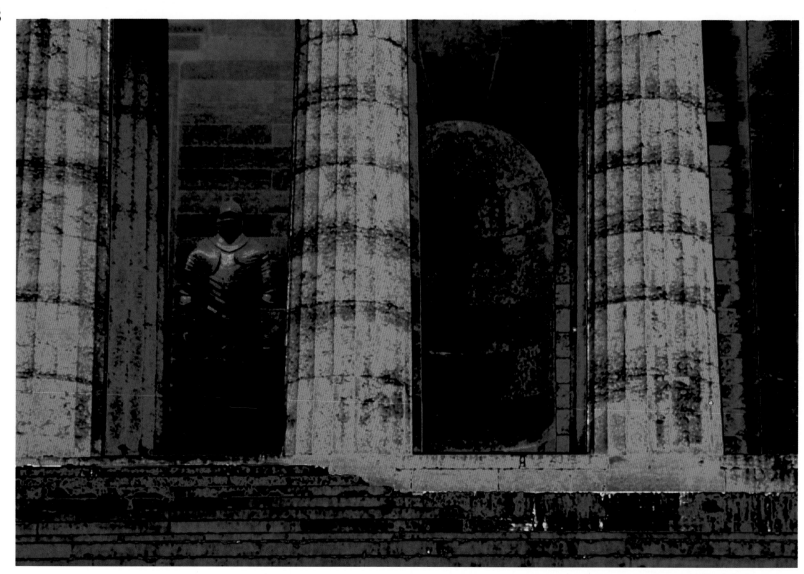

Columns
Designer **Sergio Spada**
Client **Self-promotion**
Software **Adobe Photoshop**
Hardware **Macintosh Quadra**
950

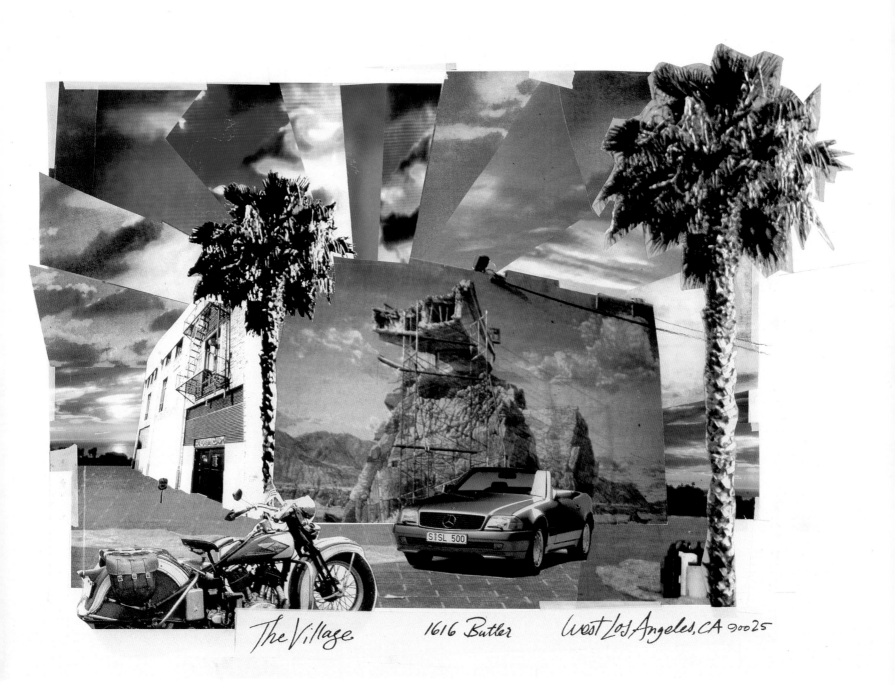

The Village *1616 Butler* *West Los Angeles, CA 90025*

Fine Art
Design Firm **Mike Salisbury**
Communications, Inc.
Art Direction **Mike Salisbury**
Photography **Mike Salisbury**
Illustration **Mary Evelyn**
McGough
Client **The Village**
Software **Adobe Photoshop**
Hardware **Macintosh Quadra**
800

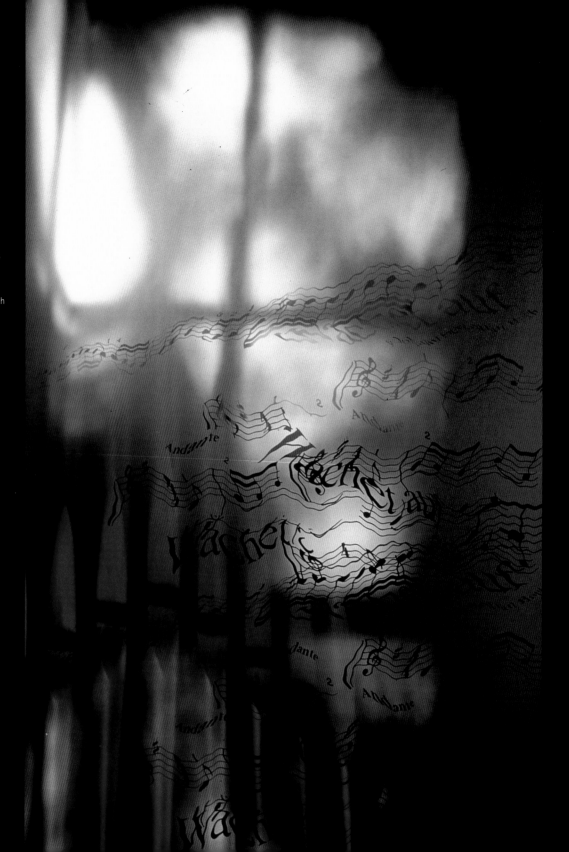

Sleepers Awake
Design Firm **Imagewright**
All Design **Annie Higbee**
Client **Self-promotion**
Software **Adobe Photoshop**
Hardware **Macintosh**

This design was created with
the use of wave filters and
composite controls in
Photoshop.

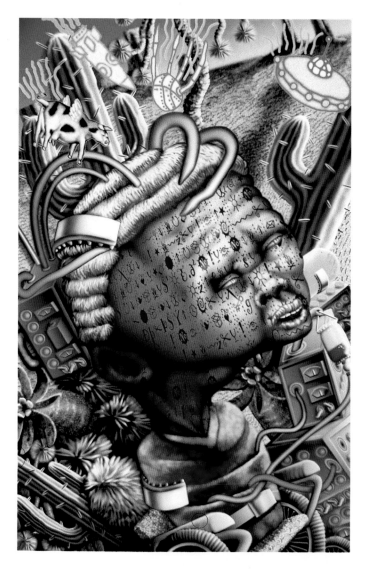

The Electric Boy
Design Firm **Eyebeam**
Art Director **Greg Carter**
Software **Adobe Photoshop,
Adobe Illustrator**
Hardware **Macintosh Quadra**

The space ships were drawn
in Illustrator and copied via
the pasteboard to a separate
Photoshop file where they
were stroked, blurred, col-
orized, and textured. The
background landscape was
created with the "diffuse dark-
en only" tool, and the tattoos
on the boy's face were created
in Illustrator using the "reme-
dy soluble" font and the "text
to path" tool.

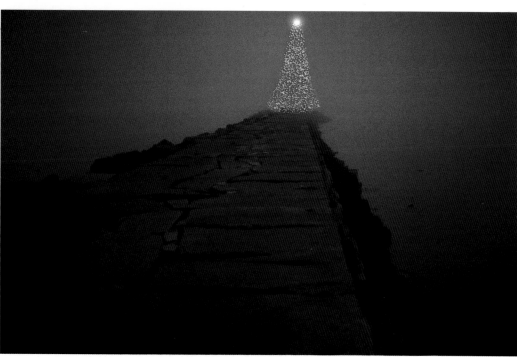

Christmas Card
Design Firm **Imagewright**
All Design **Annie Higbee**
Client **Self-promotion**
Software **Adobe Photoshop**
Hardware **Macintosh**

Two original images were
scanned into the computer
and collaged. The stem of the
tree was added with the "air-
brush" tool.

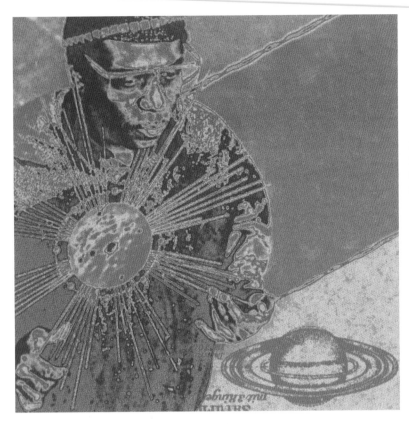

Mr. Ra, Mr. Re, Mr. Mystery
Designer **Paul Dean**
Software **Adobe Photoshop**
Hardware **Macintosh LC 3**

The Pitch
All Design **Randy Sowash**
Software **Fractal Design
Painter 2.0**
Hardware **Macintosh II SI,
Wacom tablet**

Using the "chalk" and "paint"
tools in Painter, the designer
experimented with the differ-
ent effects available with a
Wacom tablet.

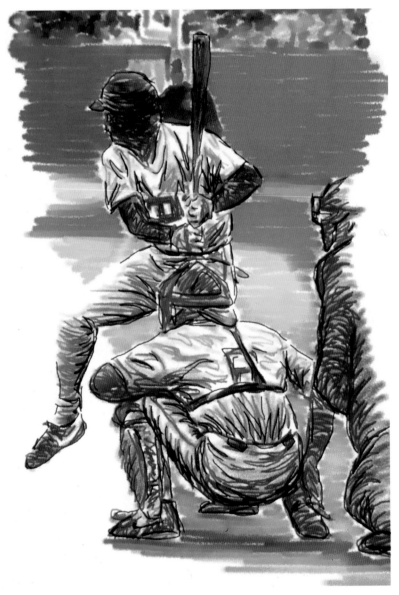

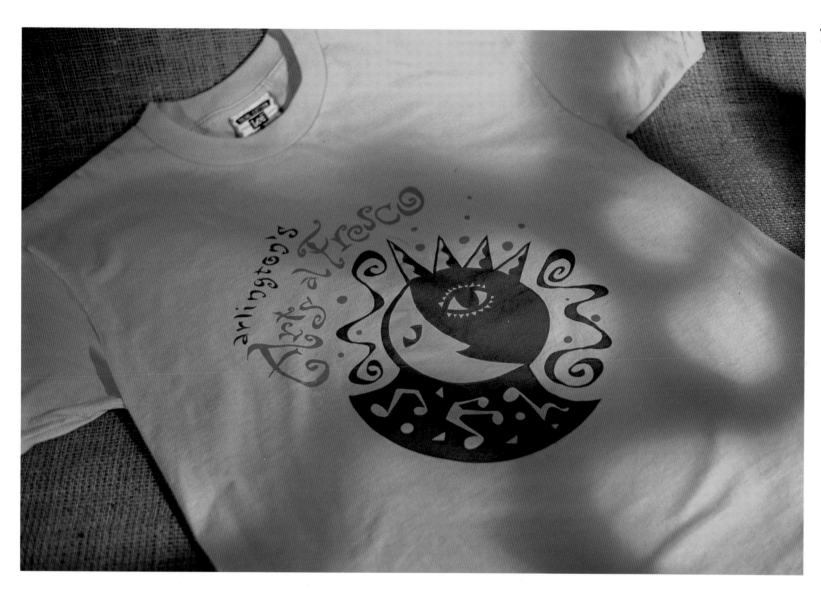

T-Shirt Logo
Design Firm **Steven Morris**
Design
All Design **Steven Morris**
Client **Arlington County,**
Virginia
Software **Adobe Illustrator 5.0**
Hardware **Power Macintosh**
6100/60, Wacom tablet

All art was hand-rendered with
the use of a Wacom tablet in
Abobe Illustrator.

Inner Dimensions
Design Firm **McGlothlin Associates, Inc.**
Designer **Gordon McGlothlin**
Software **Adobe Photoshop, Fractal Design Painter, Xaos Paint Alchemy, Kai's Power Tools**
Hardware **Macintosh IIX**

Masked Man's Temple
Designer **David Dixon**
Software **Adobe Photoshop**
Hardware **Macintosh Quadra 700**

To create this image, the designer combined original illustration with digital media techniques in Photoshop.

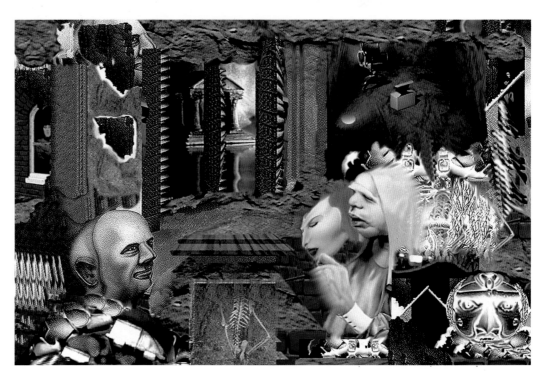

Dreamscape
Design Firm **McGlothlin**
Associates, Inc.
Designer **Gordon McGlothlin**
Software **Adobe Photoshop,**
Fractal Design Painter, Xaos
Paint Alchemy, Kai's Power
Tools
Hardware **Macintosh IIX**

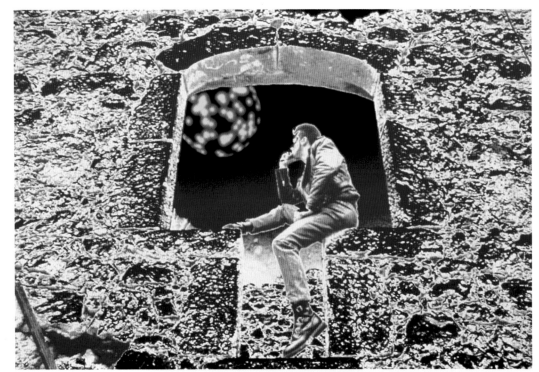

Aspirations
Designer **Sergio Spada**
Client **Self-promotion**
Software **Adobe Photoshop**
Hardware **Macintosh Quadra**
950

Pensieri
Designer **Sergio Spada**
Client **Self-promotion**
Software **Adobe Photoshop**
2.5.1
Hardware **Macintosh Quadra**
950

This was created in
Photoshop, processed on a
Macintosh 950, and was a
combination of different pho-
tography that was first
scanned in and then manipu-
lated on the screen.

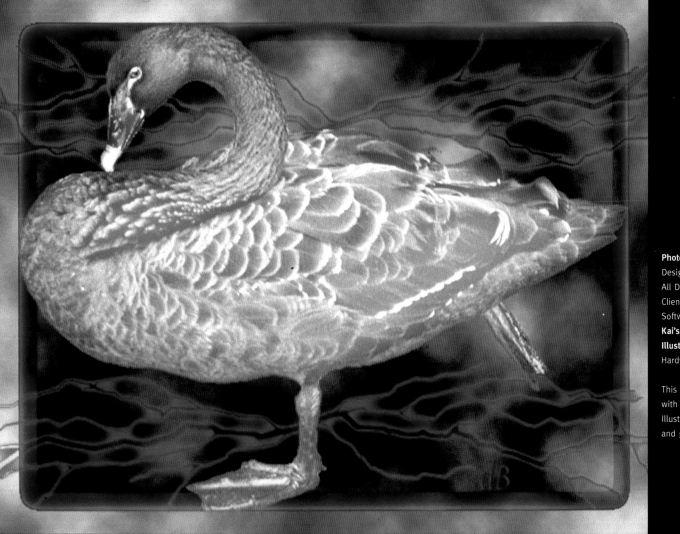

Photography Illustration
Design Firm **dD Graphics**
All Design **Darlene Benzon**
Client **Self-promotion**
Software **Adobe Photoshop,
Kai's Power Tools, Adobe
Illustrator**
Hardware **Macintosh II CI**

This design was developed
with the use of cloud filters,
Illustrator's lightening effects
and gradients on paths.

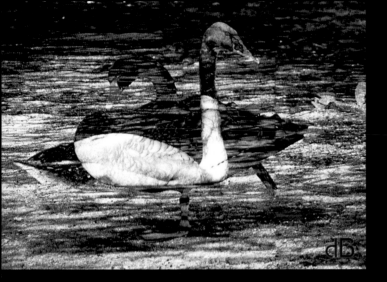

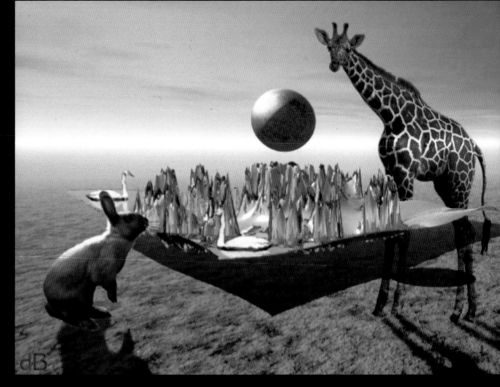

Photography Illustration
Design Firm **dD Graphics**
All Design **Darlene Benzon**
Client **dD Graphics**
Software **Adobe Photoshop**
Hardware **Macintosh II CI**

The designer used channels to combine two photographs. Starting with a Photo CD, she used the "acquire YCC" setting and added another swan image using the "calculate difference" tool.

Photography Illustration
Design Firm **dD Graphics**
All Design **Darlene Benzon**
Client **dD Graphics**
Software **KPT Bryce, Adobe Photoshop**
Hardware **Macintosh II CI**

Landscape was created in KPT Bryce, and the image was opened in Photoshop to add animals and shadows.

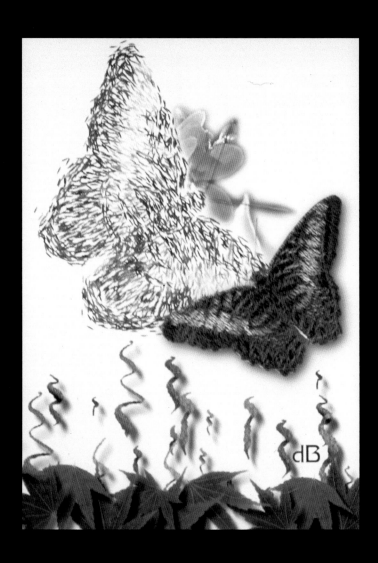

Photography Illustration
Design Firm **dD Graphics**
All Design **Darlene Benzon**
Client **dD Graphics**
Software **Fractal Design
Painter, Adobe Photoshop,
Xaos Paint Alchemy**
Hardware **Macintosh II CI**

The designer brought the
original photo into the com-
puter and made a clone of it.
The image was then manipu-
lated with the use of various
brushes in Photoshop, and a
second butterfly was added
with Paint Alchemy.

Photography Illustration
Design Firm **dD Graphics**
All Design **Darlene Benzon**
Client **dD Graphics**
Software **Adobe Photoshop,
Kai's Power Tools, Fractal
Design Explorer**
Hardware **Macintosh II CI**

The original image created in
Fractal Explorer looked a little
like a seahorse tail. The
designer copied various pieces
of this image to form a head
and body against the
smoothed background.

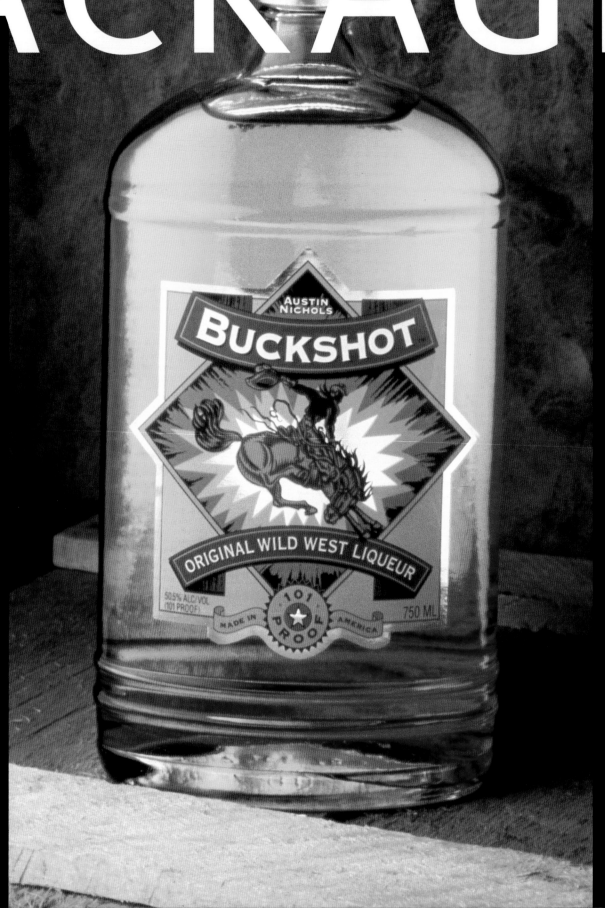

DESIGN

Liqueur Label
Design Firm **Kollberg/Johnson**
Associates
Art Director **Gary Kollberg**
Designer **Peter Johnson**
Client **Austin Nichols**
Software **Adobe Illustrator**
Hardware **Macintosh Quadra**
800

82

Banana Chip Packaging
Design Firm **Creative Company, Inc.**
Art Director **Jennifer Larsen Morrow**
Designer **Stewart Williams**
Client **Hoody's**
Software **Aldus FreeHand 3.1**
Hardware **Macintosh Quadra 700**

Multimedia Kit Packaging
Design Firm **Robert Baily Incorporated**
All Design **Dan Franklin**
Client **CrystaLake Multimedia**
Software **QuarkXPress, Live Picture, Adobe Photoshop, Aldus FreeHand**
Hardware **Power Macintosh PC 8100/80**

The design goal was to establish a unique brand identity for CrystaLake Multimedia and set them apart from the crowd in their highly competitive industry. The main photo collages were produced by combining traditional photography and stock photography. Photoshop helped to create textures, and hand-rendered type treatments were available with the power of Live Picture. The final packaging was assembled in QuarkXPress and supplied as film to the printer.

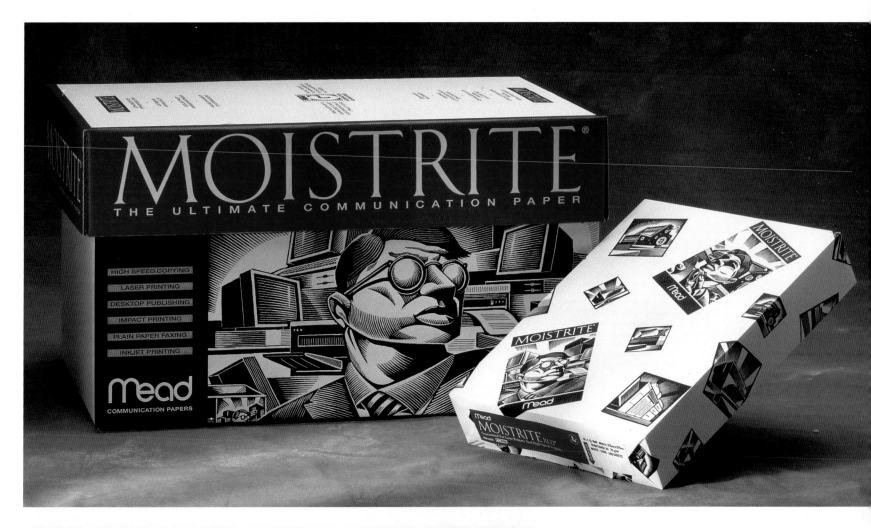

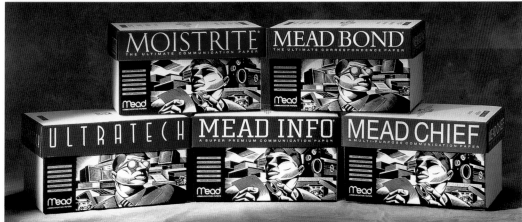

Paper Product Line Packaging
Design Firm **Northlich Stolley LaWarre Design Group**
All Design **Laura Gillespie**
Client **Mead Communication Papers**
Software **QuarkXPress, Adobe Illustrator**
Hardware **Macintosh Quadra 6.50**

Mead Communication Papers' packaging needed to convey its position of strength in the printing industry. The design firm created a system that would work with all of this company's products. Each product has a carton and ream wrapper package, and the lid graphics change by brand. The illustration style was chosen to convey the hard working industry with a hero perspective on the customer. The scratchboard technique worked well with the limitations of the flexo-printing that was required. A combination of original hand-drawn art and computer-generated art made in Illustrator and QuarkXPress was used in this package design.

84

Mouse
Design Firm **Ampersand Design Group, Reiser & Reiser Advertising and Marketing**
Art Director **Tino Reiser**
Designer **Dan González**
Client **Intcomex**
Software **Adobe Illustrator, Adobe Photoshop**
Hardware **Macintosh Quadra 840 A**

For this package, the designer placed his hand directly on the scanner and scanned. The scan was brought into Photoshop, and the "clouds difference" filter was applied to the image.

Speakers
Design Firm **Ampersand Design Group, Reiser & Reiser Advertising and Marketing**
Art Director **Tino Reiser**
Designer **Dan González**
Client **Intcomex**
Software **Adobe Illustrator, Adobe Photoshop**
Hardware **Macintosh Quadra 840 A**

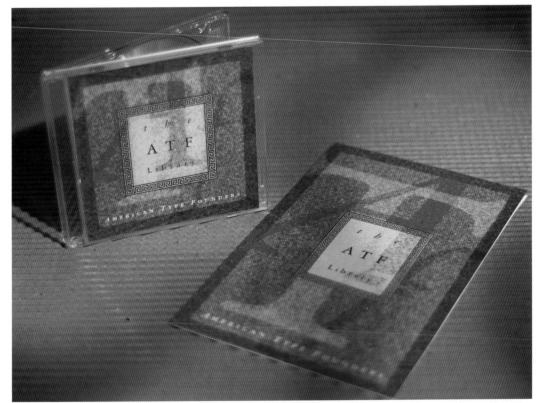

Compact Disk Cover, Brochure
Design Firm **Steven Morris Design**
All Design **Steven Morris**
Client **American Type Founders**
Software **Adobe Illustrator, Adobe Photoshop, QuarkXPress**
Hardware **Power Macintosh 6100/60**

Background art was created with fonts in Illustrator 5.5. It was then taken into Photoshop and texture manipulated. The image was composited in QuarkXPress.

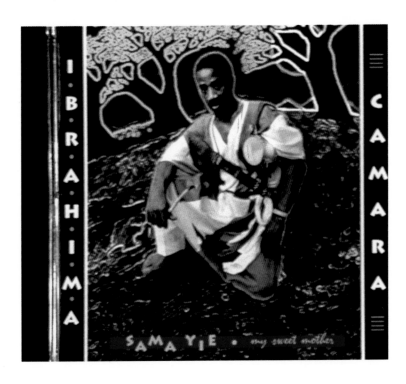

Compact Disk Cover
Design Firm **Beth Santos Design**
All Design **Beth Santos**
Client **Soundworks**
Software **Adobe Photoshop, QuarkXPress**
Hardware **Macintosh Quadra 650**

86

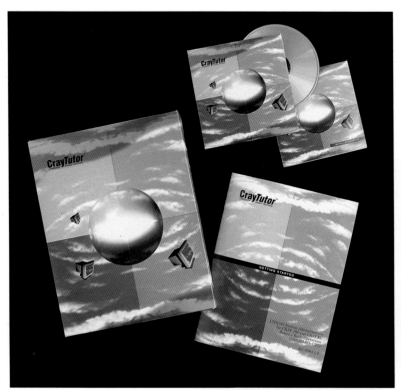

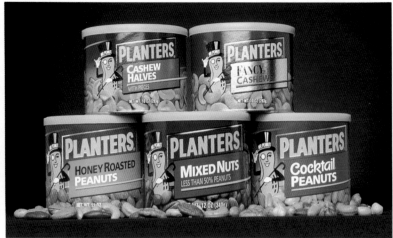

Peanuts
Design Firm **Kollberg/Johnson Associates**
Art Director **Gary Kollberg**
Designer **Kollberg/Johnson Associates**
Client **Planters**
Software **Adobe Illustrator**
Hardware **Macintosh Quadra 800**

Compact Disk
Design Firm **Martin Ross Design**
Art Directors **Ross Rezac, Martin Skoro**
Designers **Ross Rezac, Martin Skoro**
Client **Cray Research**
Software **Adobe Photoshop, Adobe Illustrator, QuarkXPress**
Hardware **Macintosh IIC**

Designers used a spherical filter to create this package design.

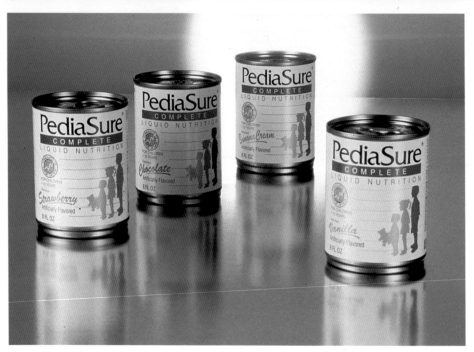

Baby Formula
Design Firm **Kollberg/Johnson Associates**
Art Director **Penny Johnson**
Designer **Peter Johnson**
Client **Ross Laboratories**
Software **Adobe Illustrator**
Hardware **Macintosh Quadra 800**

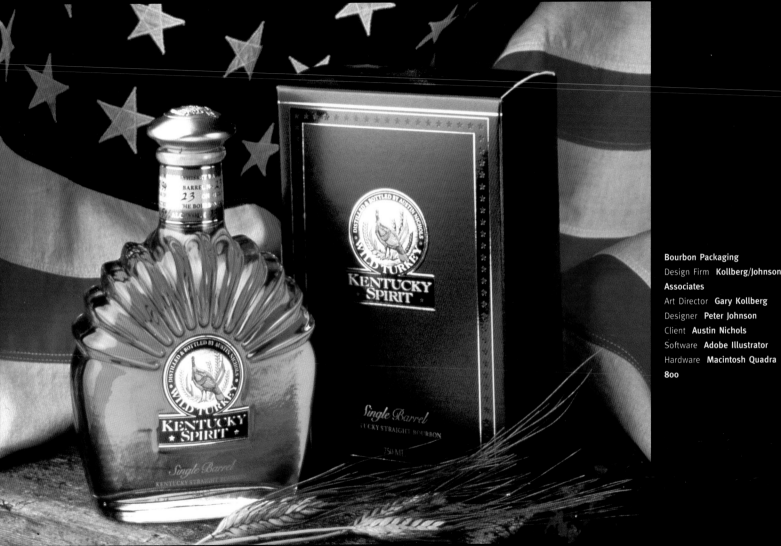

Bourbon Packaging
Design Firm **Kollberg/Johnson Associates**
Art Director **Gary Kollberg**
Designer **Peter Johnson**
Client **Austin Nichols**
Software **Adobe Illustrator**
Hardware **Macintosh Quadra 800**

Chocolate Bar Packaging, Box Design
Design Firm **Rapp Collins Communications**
All Design **Bruce Edwards**
Client **Nestlé-Beich**
Software **QuarkXPress**
Hardware **Macintosh FX**

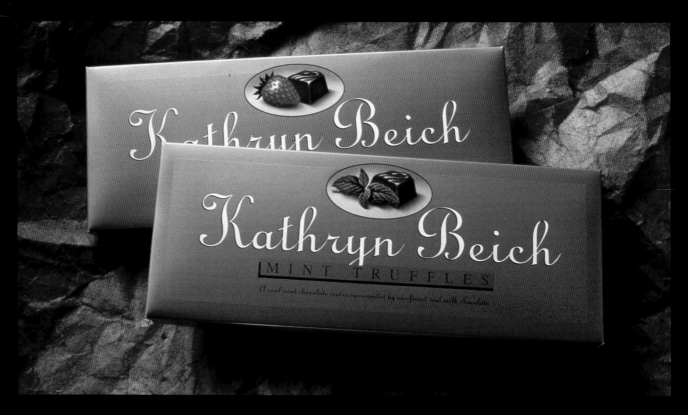

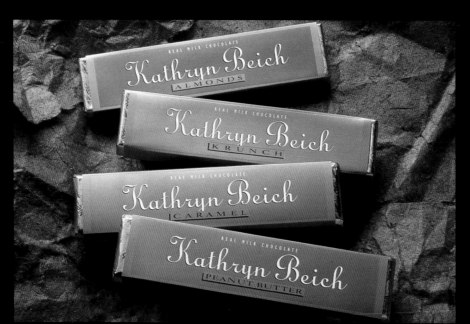

Coffee
Design Firm **Elton Ward Design**
Art Director **Steve Coleman**
Designer **Chris De Lisen**
Client **Elton Ward Design**
Photographer **Natalie Arditto, Andrew Kay**
Software **Adobe Illustrator, Adobe Photoshop**
Hardware **Macintosh Quadra 950**

Shakas signature rendered by hand, scanned and auto-traced. All other elements were illustrated in Illustrator and refined in Photoshop to give a rustic, handmade appearance.

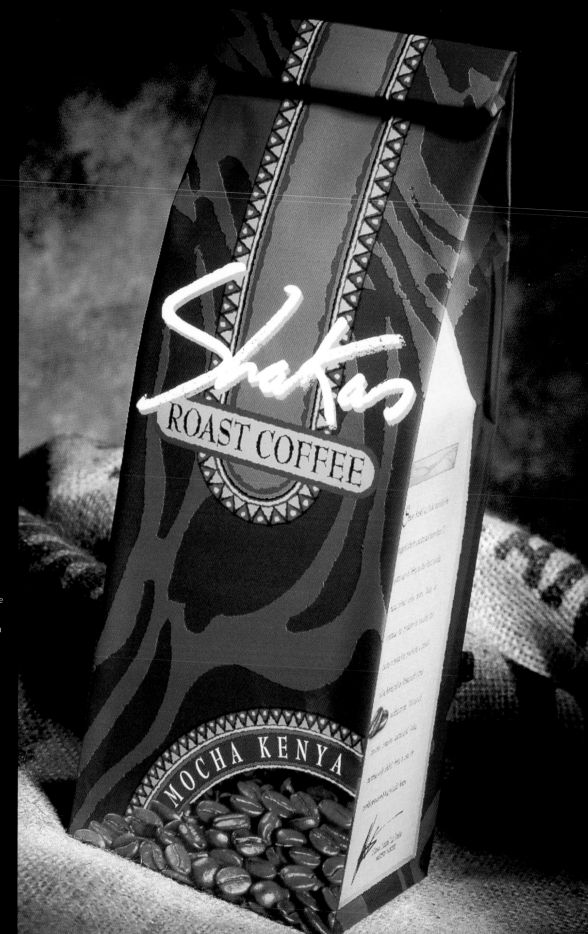

Software Packaging
Design Firm **Robert Bailey Incorporated**
Art Director **Robert Bailey**
Designer **Ellen Bednarek**
Client **Consumer Technology Northwest**
Software **Aldus FreeHand**
Hardware **Macintosh Power PC 1700**

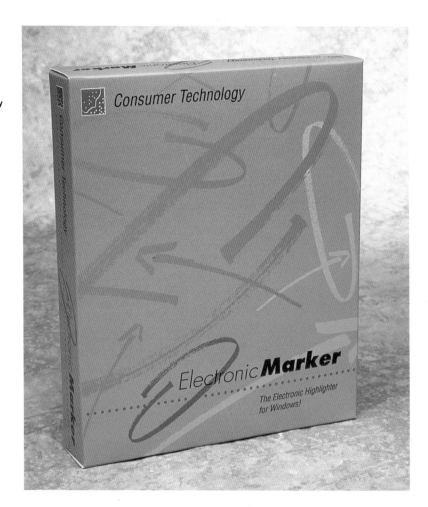

Game Cover
Design Firm **Parker Brothers**
All Design **Steve Krupsky**
Software **Adobe Illustrator 5.0, Aldus FreeHand**
Hardware **Macintosh Quadra 800**

The illustrations were drawn with a black Pentel sign pen, scanned into stream line and cleaned up in Illustrator. Logo was created in Illustrator as line art, then both logo and illustrations were imported into Aldus FreeHand for final production

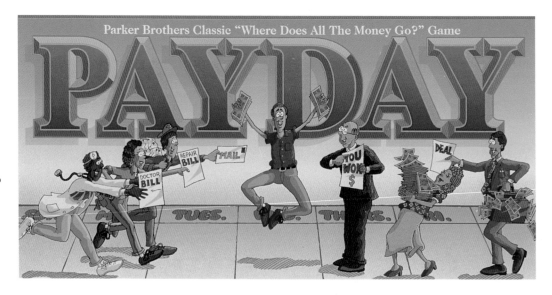

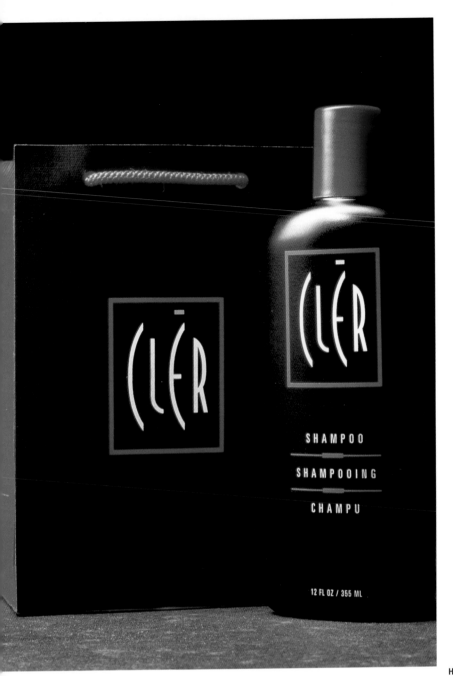

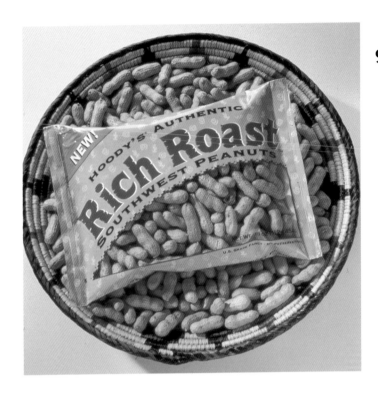

Hair Care Product
Design Firm **Rapp Collins
Communications**
All Design **Bruce Edwards**
Client **Dow Brands**
Software **Adobe Illustrator
5.0**
Hardware **Macintosh Centris
650**

The logo for this product was hand drawn, scanned into the computer, and redrawn in Illustrator. Once the design was approved it was very easy to reduce and enlarge the design to the various bottle size and shapes with the Illustrator program.

Peanuts
Design Firm **Creative
Company, Inc.**
Art Director **Jennifer Larsen
Morrow**
Designer **Dan Franklin**
Client **Hoody's (Rich Roast
Peanuts)**
Software **Aldus FreeHand 3.1**
Hardware **Macintosh Centris
660 AV**

Christmas Promotion
Design Firm **Zubi Design**
Designers **Kristen Balouch,**
Omid Balouch
Client **Boxart, Inc.**
Software **Aldus FreeHand**
Hardware **Macintosh II C**

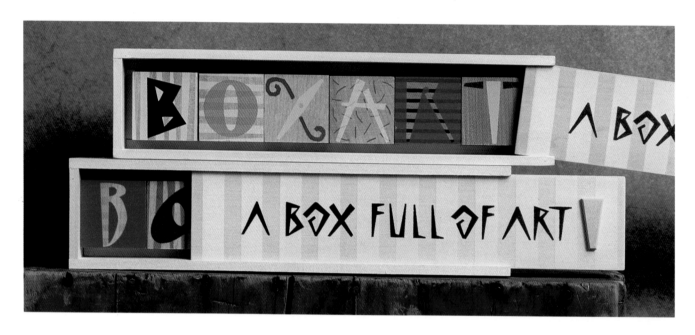

Retail Product
Design Firm **Zubi Design**
Designers **Kristen Balouch,**
Omid Balouch
Client **Guggenheim Museum**
Soho
Software **Aldus FreeHand**
Hardware **Macintosh II C**

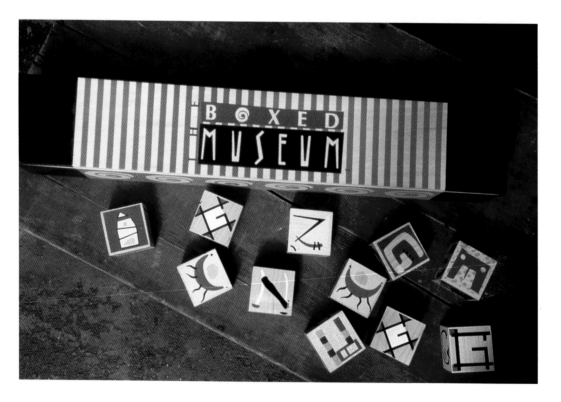

Christmas Promotion
Design Firm **Zubi Design**
Designers **Kristen Balouch,**
Omid Balouch
Client **Boxart, Inc.**
Software **Aldus FreeHand**
Hardware **Macintosh II C**

Box and blocks were designed
in Aldus FreeHand and output
for additional work on the art.

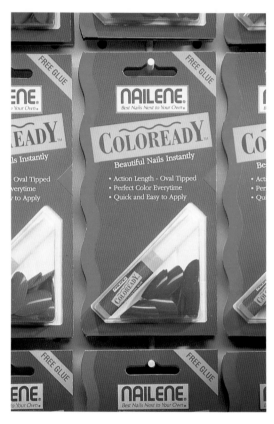

Appetizer Packaging

Design Firm

Shimokochi/Reeves

Art Directors **Mamoru**

Shimokochi, Anne Reeves

Designer **Mamoru Shimokochi**

Client **Camino Real Foods, Inc.**

Software **Adobe Illustrator**

Hardware **Macintosh**

Nail Products

Design Firm

Shimokochi/Reeves

Art Directors **Mamoru**

Shimokochi, Anne Reeves

Designer **Mamoru Shimokochi**

Client **Pacific World**

Corporation

Software **Adobe Illustrator**

Hardware **Macintosh**

Skin Products
Design Firm
Shimokochi/Reeves
Art Directors **Mamoru**
Shimokochi, Anne Reeves
Designer **Mamoru Shimokochi**
Client **Dep Corporation**
Software **Adobe Illustrator**
Hardware **Macintosh**

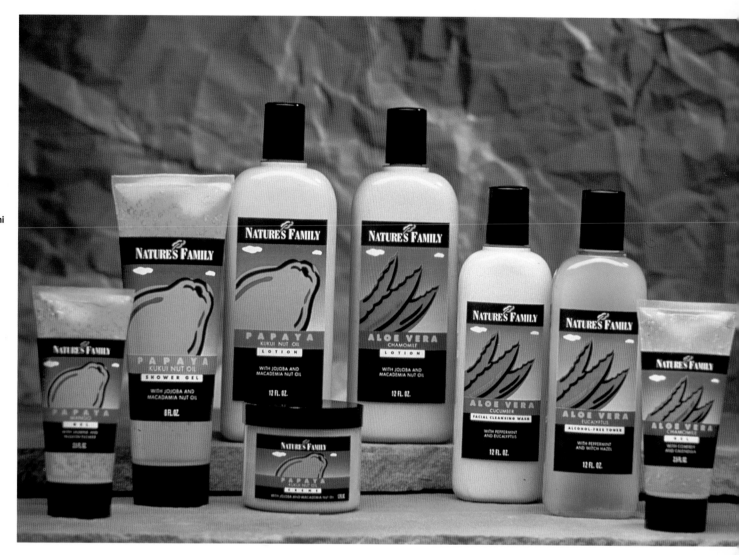

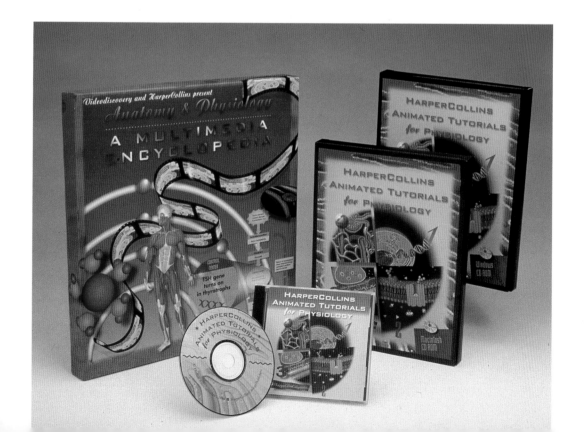

Software, Laser Disk
Art Directors **Zina Scarpulla,**
Rosanne Lufrano
Designers **Zina Scarpulla,**
Rosanne Lufrano
Client **HarperCollins**
Publishers
Software **QuarkXPress, Adobe**
Photoshop, Adobe Illustrator
Hardware **Power Macintosh**
8100/80, Macintosh Quadra
950

Illustrations were composed
from screen grabs and assem-
bled in Photoshop. All pieces
were output directly from disk
to film: all art was live.

96

Specialty Products
Design Firm **Hornall Anderson Design Works**
Art Director **Jack Anderson**
Designers **Jack Anderson, Julie Lock, David Bates, Julia LaPine**
Client **Starbucks Coffee Company**
Software **Aldus FreeHand**
Hardware **Power Macintosh 8100 72/1000**

Use of a warm color palette depicts a more approachable and eco-conscious image. Wherever possible, the packaging was produced with environmentally friendly processes and components, including recycled and recyclable stocks, and soy-based inks.

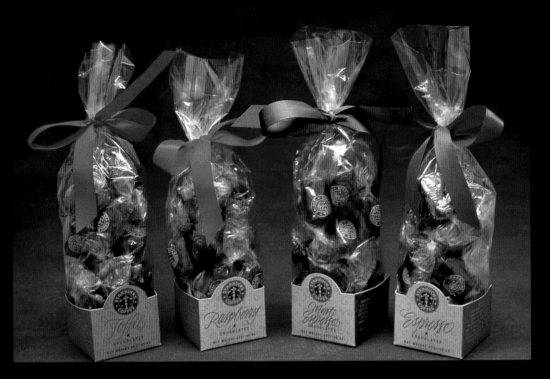

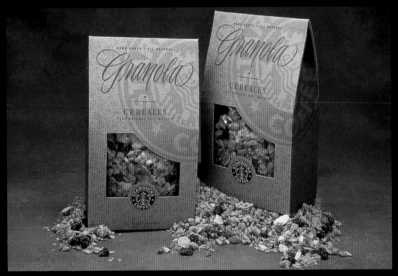

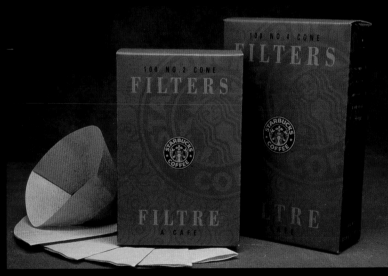

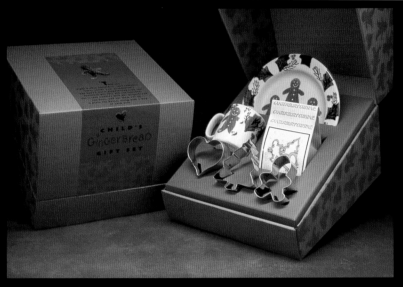

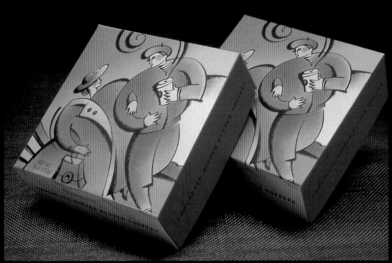

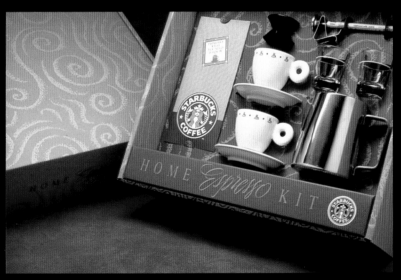

Caltex Oil
Design Firm **Elton Ward Design**
Art Director **Steve Coleman**
Designer **Chris De Lisen, Simon Macrae**
Client **Caltex Oils Australia**
Photographer **Andrew Kay**
Software **Adobe Illustrator 5.5**
Hardware **Macintosh Quadra 950**

Illustrations were drawn by hand and scanned as a template into Illustrator where they were redrawn in more detail. Elements were refined and finally separated through QuarkXPress.

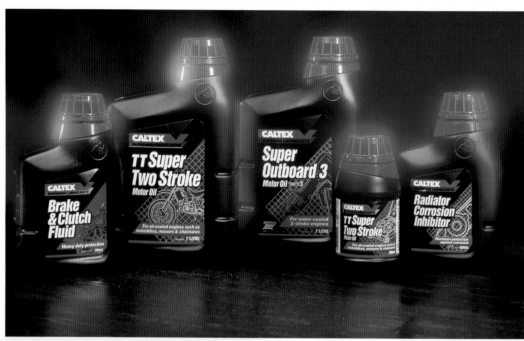

Shoe Brand Identity
Design Firm **Elton Ward Design**
Art Director **Steve Coleman**
Designer **Chris De Lisen**
Client **Dunlop Footwear**
Software **Adobe Illustrator 5.5**
Hardware **Macintosh Quadra 950**

Initial rough image was scanned as a template. Illustration was then built and refined in Illustrator to produce a 2-color label.

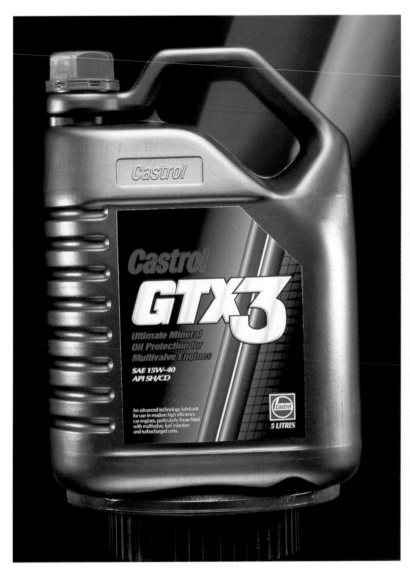

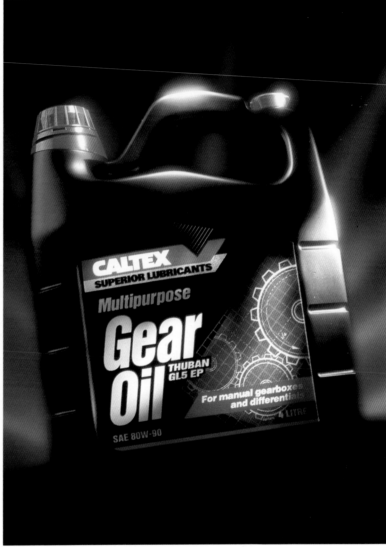

Castrol GTX 3 Oil
Design Firm **Elton Ward Design**
Art Director **Steve Coleman**
Designer **Simon Macrae**
Client **Castrol Australia**
Photographer **Andrew Kay**
Software **Adobe Illustrator 5.5**
Hardware **Macintosh Quadra 950**

Entire package was created in Illustrator. Blends were used in
the GTX 3 logo to create a metallic surface texture. All blends
are created using the conventional stepping method in
Illustrator. Stroked keylines add highlights and break vignettes
to create movement.

Caltex Oil
Design Firm **Elton Ward Design**
Art Director **Steve Coleman**
Designers **Chris De Lisen, Simon Macrae**
Client **Caltex Oils Australia**
Photographer **Andrew Kay**
Software **Adobe Illustrator 5.5**
Hardware **Macintosh Quadra 950**

Packaging was hand-illustrated and scanned on a flatbed scan-
ner as a template. The image was built entirely in Illustrator.

100

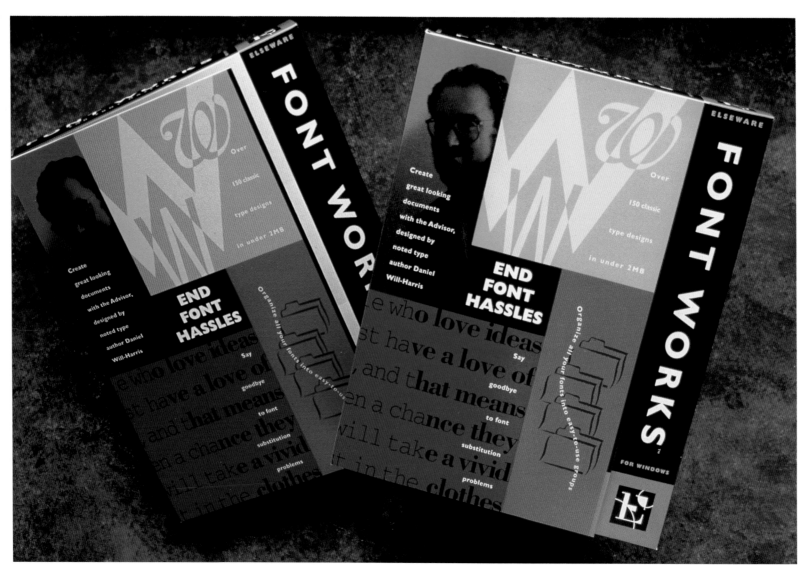

Software Packaging
Design Firm **Hornall Anderson**
Design Works
Art Director **Jack Anderson**
Designers **Jack Anderson, Leo**
Raymundo, Debra Hampton
Client **ElseWhere Corporation**
Software **Aldus FreeHand,**
Adobe Photoshop
Hardware **Power Macintosh**
8100 72/1000

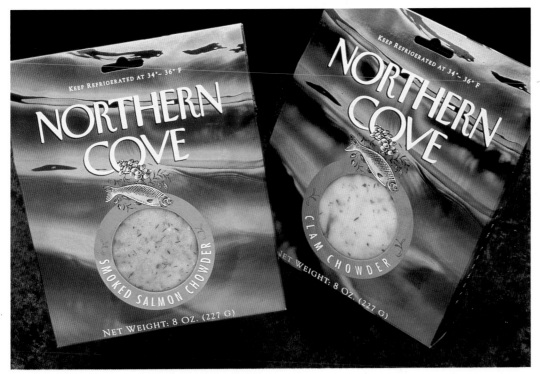

Soup
Design Firm **Hornall Anderson Design Works**
Art Director **John Hornall**
Designers **Jack Anderson, Scott Eggers**
Client **Northern Cove**
Software **Aldus FreeHand, Adobe Photoshop**
Hardware **Power Macintosh 8100 72/1000**

The dramatic water photography surrounding the product suggests the notion of ingredients fresh from the sea, and by shifting the color from one flavor variety to the next, designers were able to create a strong visual distinction between them. The package's nautical quality sets off the product to its best advantage.

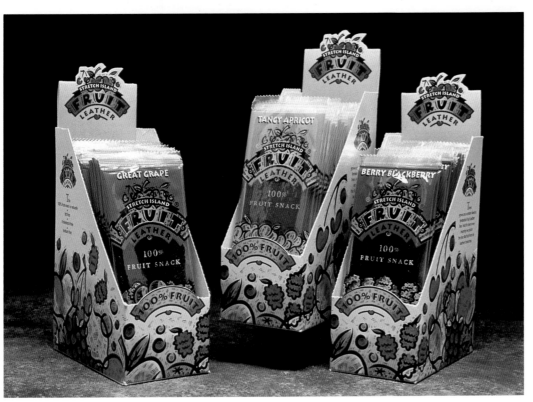

Fruit Snack
Design Firm **Hornall Anderson Design Works**
Art Director **Jack Anderson**
Designers **Jack Anderson, Mary Hermes, Leo Raymundo**
Client **Stretch Island**
Software **Aldus FreeHand, Adobe Illustrator**
Hardware **Power Macintosh 8100 72/1000**

The strategy was to create a logo and package attitude that would look fun and healthy. The logo and the exterior container play off a bright, festive color palette. Playful graphic interpretations of the different fruit leather varieties and contemporary typographic treatments were used. The two different product lines are differentiated by container selections.

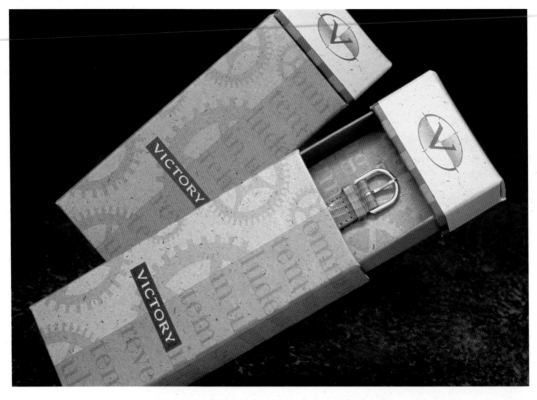

Watch Packaging
Design Firm **Hornall Anderson Design Works**
Art Director **John Hornall**
Designers **John Hornall, Julia LaPine, Jill Bustamante, Heidi Favour, Bruce Branson-Meyer**
Client **Callanen International/Victory**
Software **Aldus FreeHand**
Hardware **Power Macintosh 8100 72/1000**

The designers made use of a rich, subtle color palette to achieve a sophisticated personality. Background patterns were created using Latin phrases about time and images of watch gears to add visual interest to the packaging and to play off of the other graphic elements. Different color palettes distinguish between women's and men's watch packages.

Bread Mix
Design Firm **Hornall Anderson Design Works**
Art Director **Jack Anderson**
Designers **Jack Anderson, John Anicker, Bruce Branson-Meyer**
Client **Continental Mills/Krusteaz**
Software **Aldus FreeHand**
Hardware **Power Macintosh 8100 72/1000**

Illustrations created by hand and brought into FreeHand depict a warmer, more "home-style" appearance for this bread mix package.

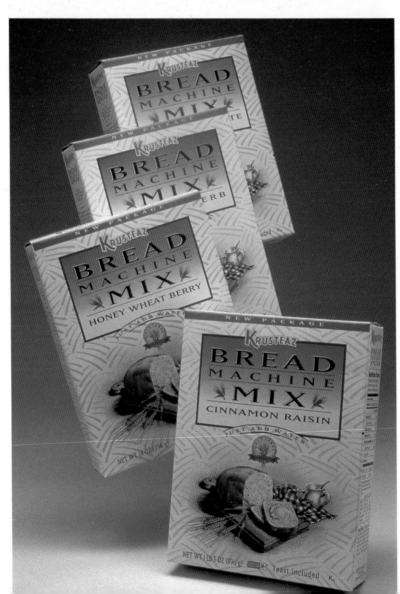

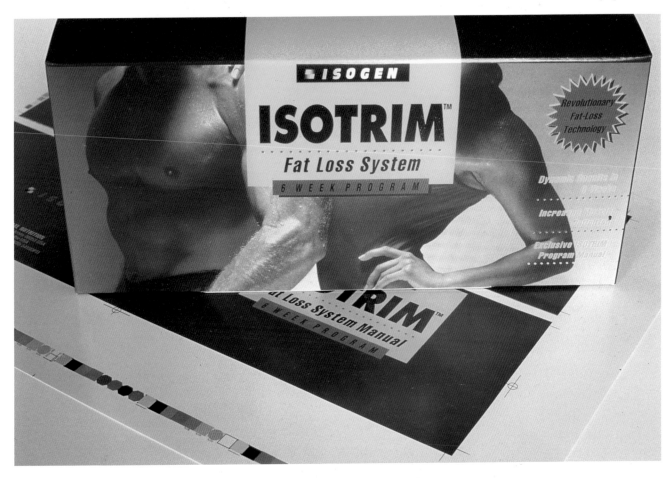

Weight Loss Product
Design Firm **The Design Company**
All Design **Marcia Romanuck**
Client **Vitamin Health Centers**
Software **Adobe Photoshop, QuarkXPress**
Hardware **Macintosh II CI**

The designer played with the image in Photoshop in various combinations of colors and chose a 4-color duotone with overall fill. The package printed as a 5-color piece with a yellow chartreuse panel of type used for the product heading.

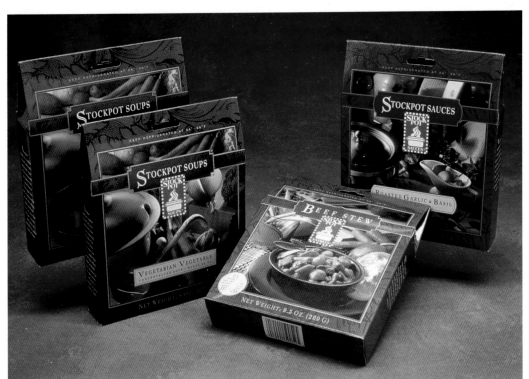

Soup
Design Firm **Hornall Anderson Design Works**
Art Director **John Hornall**
Designers **John Hornall, Scott Eggers**
Client **Stock Pot**
Software **Aldus FreeHand, Adobe Photoshop**
Hardware **Power Macintosh 8100 72/1000**

Since taste appeal and fresh ingredients were the product's key distinguishing characteristics, the designers used original photography to illustrate the product's packaging.

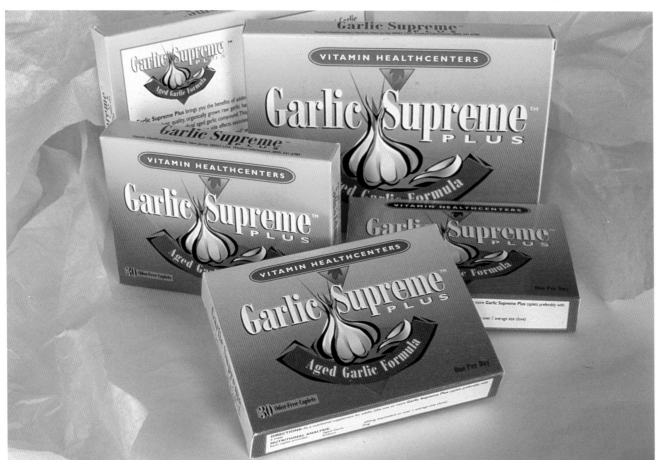

Vitamins
Design Firm **The Design Company**
Art Director **Marcia Romanuck**
Designer **Allison Scheel**
Client **Vitamin Health Centers**
Software **Adobe Illustrator, QuarkXPress**
Hardware **Power Macintosh PC**

Art was created in Illustrator and Photoshop: the Illustrator version was stronger and was imported into QuarkXPress to create the overall package.

Candy
Design Firm **The Design Company**
Art Director **Marcia Romanuck**
Designers **Fran McKay, Marcia Romanuck**
Client **Metropolis Fine Confections**
Software **QuarkXPress**
Hardware **Power Macintosh 9100**

Large panels of a lipstick kiss impression were created in different neon colors on a 4-color block background. The panels were mounted to block of foam cover and used as a display at a trade show.

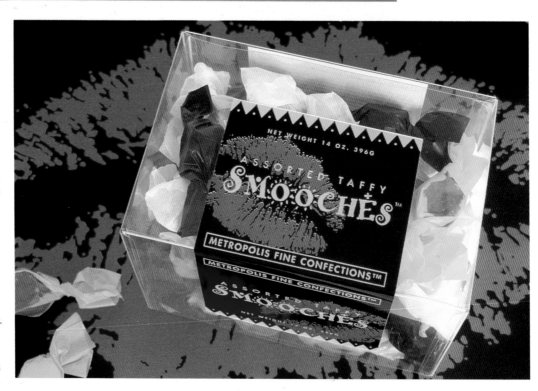

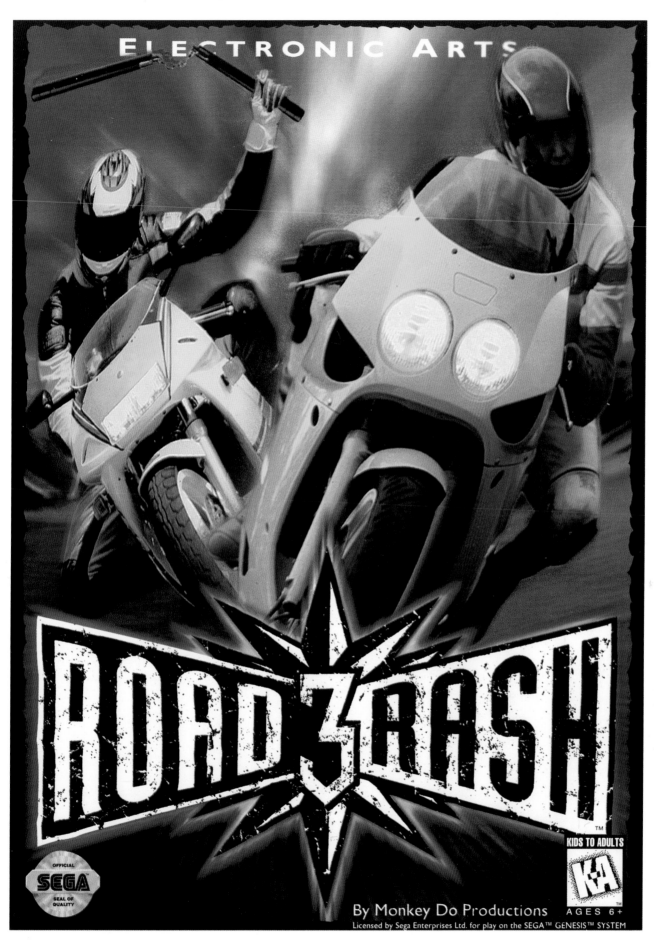

Video Game
Design Firm **Electronic Arts**
All Design **Corey Higgins**
Client **Monkey Do-Productions**
Software **Adobe Photoshop,
Adobe Illustrator**
Hardware **Power Macintosh
8100/110**

Original art was scanned into
the computer. Color fill features
were used to create quad-
tones. The designer combined
merge tools and feather blow-
out filters in the "levels" mode
to develop this packaging.

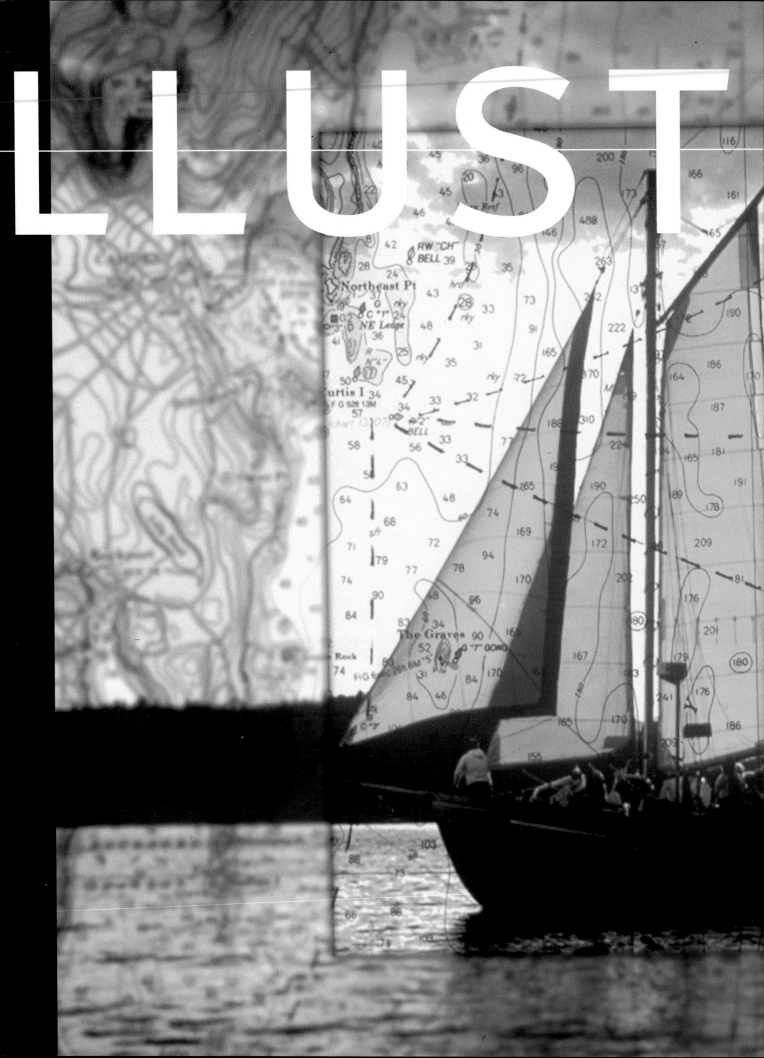

LLUST

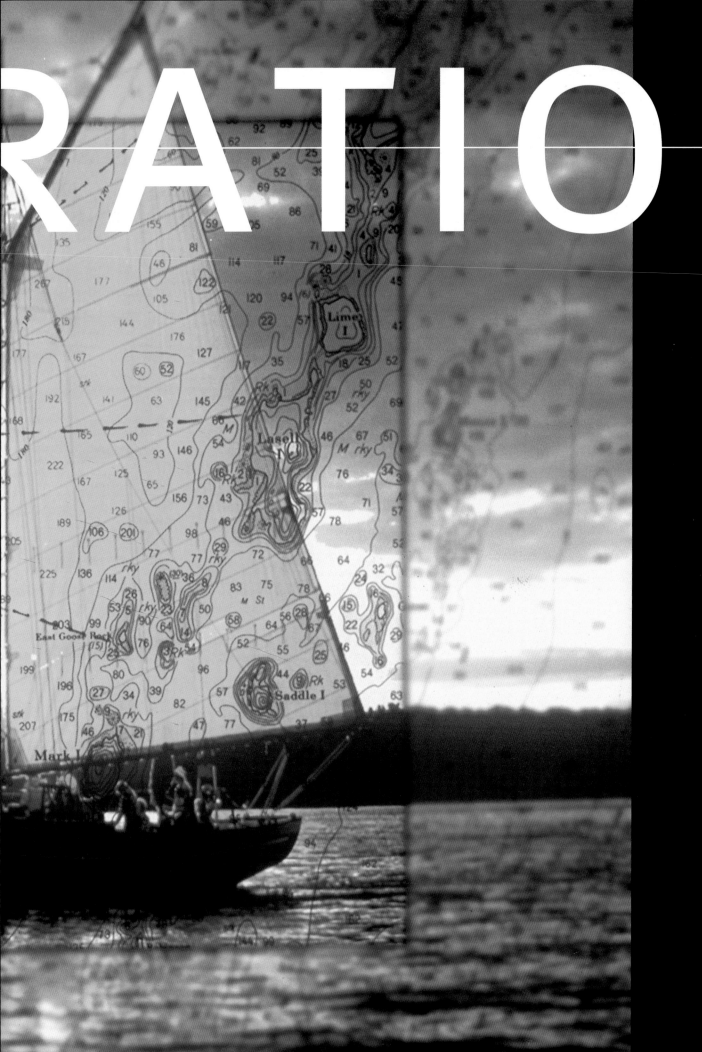

RATION

Poster Illustration
Design Firm **Imagewright**
All Design **Annie Higbee**
Client **The Schooner OLAD**
Software **Adobe Photoshop**
Hardware **Macintosh**

The designer photographed
the boat and scanned the top
of the image with a United
States Coast Guard map.
Mask and blur filters were
used to create the frame
around the image.

108

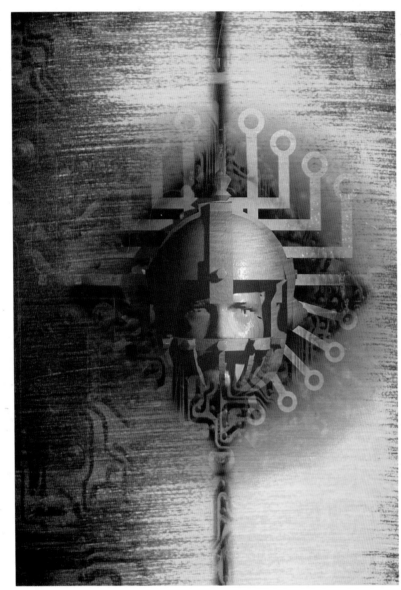

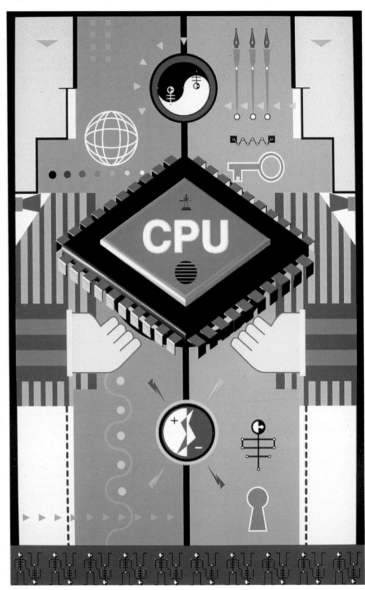

Intelligent Network

CPU

Design Firm **IDG(HK)**
Communication
Art Director **Eric Lam**
Client **PCWorld Hong Kong**
Software **Strata StudioPro 1.0,**
Adobe Photoshop 2.5.1
Hardware **Macintosh Quadra**
840 AV, 40M RAM/1G hard disk

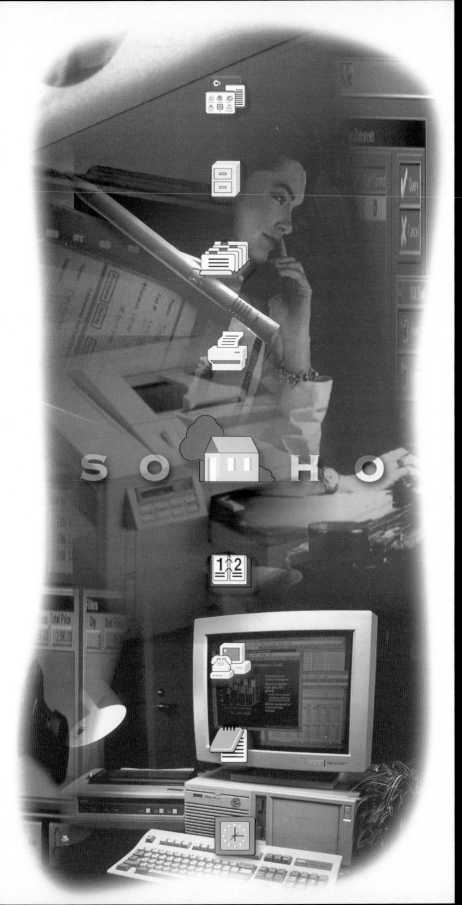

Small Office Home Office

Direct Mail Newsletter
Design Firm **Jim Lange Design**
All Design **Jim Lange**
Client **Kraft Foods**
Software **Adobe Illustrator**
Hardware **Macintosh II Ci**

This entire image was drawn
and altered on the computer in
Illustrator.

T-Shirt
Design Firm **Jim Lange Design**
All Design **Jim Lange**
Client **Self-promotion**
Software **Adobe Illustrator**
Hardware **Macintosh II Ci**

This T-shirt design began as an
ink drawing. The image was then
scanned into the computer and
colored with Illustrator.

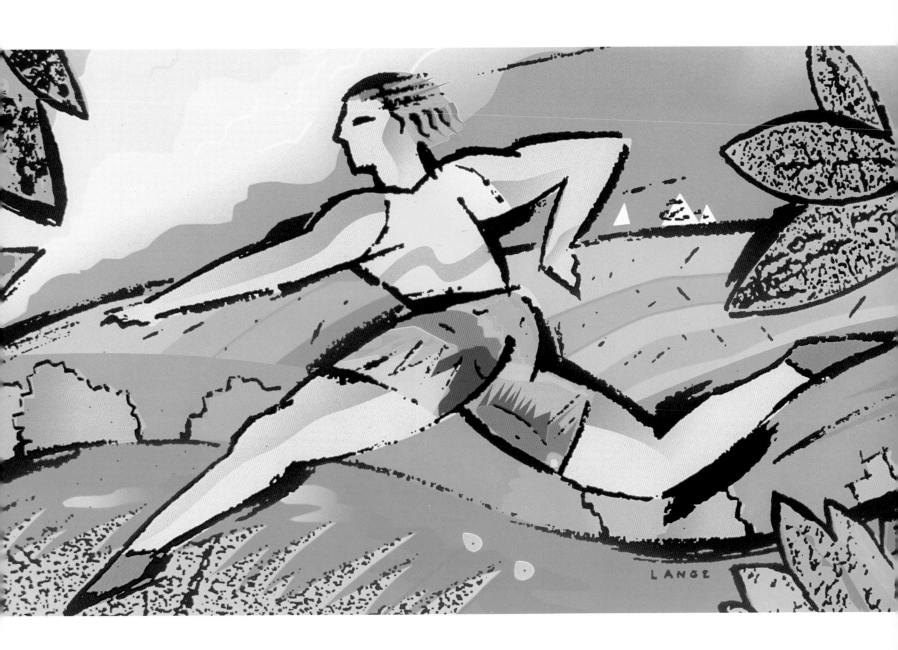

Triathalon T-Shirt
Design Firm **Jim Lange Design**
All Design **Jim Lange**
Client **CPR Events**
Software **Adobe Illustrator**
Hardware **Macintosh II CI**

This ink drawing was scanned
into the computer where the col-
ors were filled in and enhanced.

112

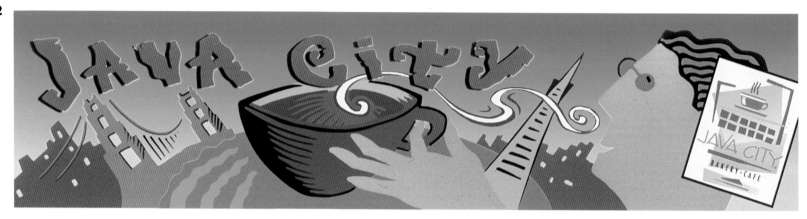

Coffee Store Illustration
Design Firm **Jim Lange Design**
Art Director **Roy Koerner /**
Runyon-Saltzman & Einhorn Inc.
Designer **Jim Lange**
Client **Java City**
Software **Adobe Illustrator**
Hardware **Macintosh II Ci**

The designer used Illustrator to colorize and enhance this ink drawing.

Commemorative Poster
Design Firm **Sophisticated Dog Design Group**
All Design **Ken Morris, Jr.**
Client **St. Joseph's Hospital and Medical Center**
Software **Adobe Illustrator 5.5**
Hardware **Power Macintosh PC 7100/66**

A preliminary pencil sketch was scanned and opened as a template in Illustrator. The theater, the background cars, the crowd of people, and the foreground car images were all created on separate layers and worked on individually. The "blend" tool was used to create the modeling for the foreground car in order to achieve the irregularly shaped blends. The "gradient" tool was used in developing the gradation for the type and the theater wall, and a customized color palette was used for the colorization.

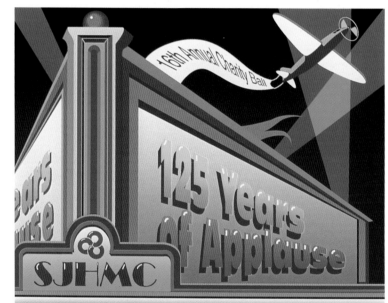

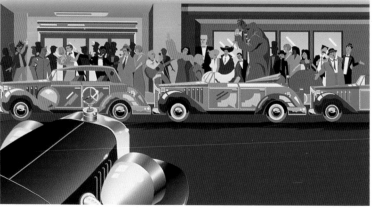

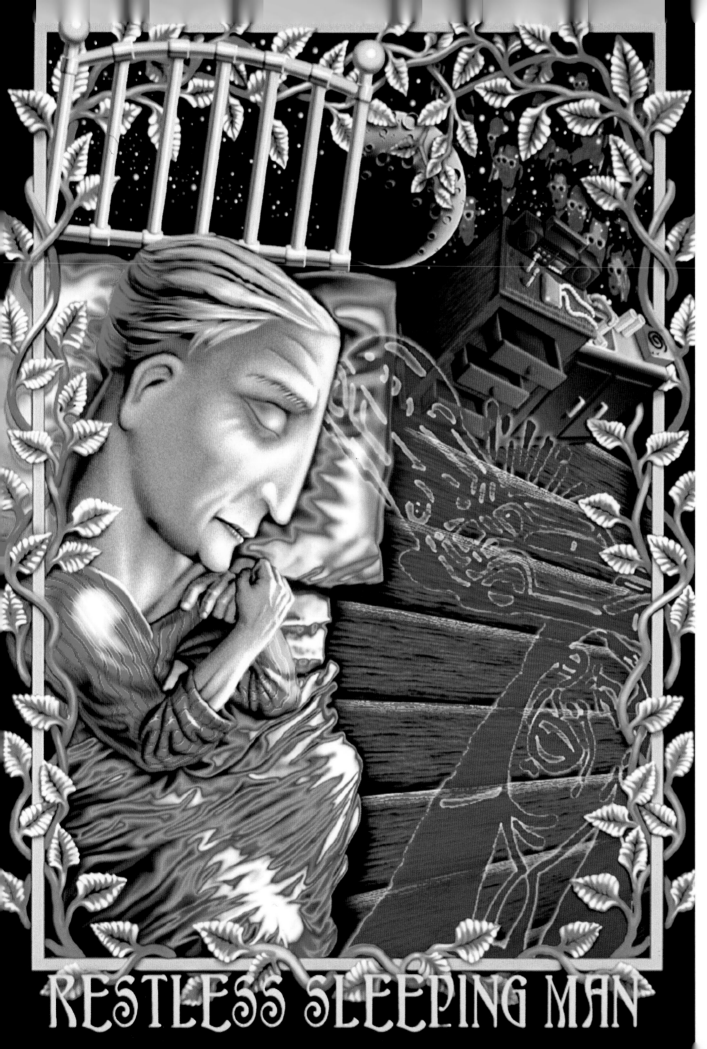

RESTLESS SLEEPING MAN

Restless Sleeping Man
Design Firm **Eyebeam**
All Design **Greg Carter**
Client **Self-promotion**
Software **Adobe Illustrator,
Adobe Photoshop, KPT Bryce**
Hardware **Macintosh**

Scanned-in images were
combined with Photoshop
painting techniques in various
files to produce this design.

Compact Disk Cover
Design Firm **Ampersand Design Group**
All Design **Dan González**
Client **Spee-klein**
Software **Adobe Illustrator, Adobe Photoshop, Strata StudioPro**
Hardware **Macintosh Quadra 840 AV**

When working in StudioPro and generating a cloud background, the designer avoided use of the "cloud generator" tool, because it tiles a pattern of a cloud and looks unrealistic. He rendered the file instead with an alpha channel and imported it into Photoshop. The selection was then pasted in a cloud background taken from a Photo CD.

Corporate Greeting Card
Design Firm **Ampersand Design Group**
All Design **Dan González**
Client **Turkel Advertising**
Software **Aldus FreeHand, Adobe Illustrator, Adobe Photoshop**
Hardware **Macintosh Quadra 840 AV**

To render glass in Photoshop, the designer used an image from a Photo CD that would normally be reflected. He blurred the image and pasted it into the glass shape. The opacity was adjusted to make the selection appear semi-transparent, like a reflection.

Direct Mail Brochure Cover
Design Firm **Ampersand Design Group**
All Design **Dan González**
Client **Miami Advertising School**
Software **Adobe Photoshop, Strata StudioPro**
Hardware **Macintosh Quadra 840 AV**

The designer merged a shaded, rendered three-dimensional image with a wireframe rendered three-dimensional image. To do this, he rendered both files at the same size and resolution. In Photoshop, he copied the wire frame onto the shaded file and used the "darken" mode to make the white transparent.

118

T-Shirt
Design Firm **Steve Krupsky Design**
All Design **Steve Krupsky**
Client **Bach Designs Ltd**
Software **Adobe Illustrator, Aldus FreeHand, Adobe Photoshop**
Hardware **Guildry 650**

Typography and basketball court image were created in Illustrator. Textures, drop shadow basketball, and streaks were created in Photoshop, and everything was then brought into FreeHand for coloring and final output.

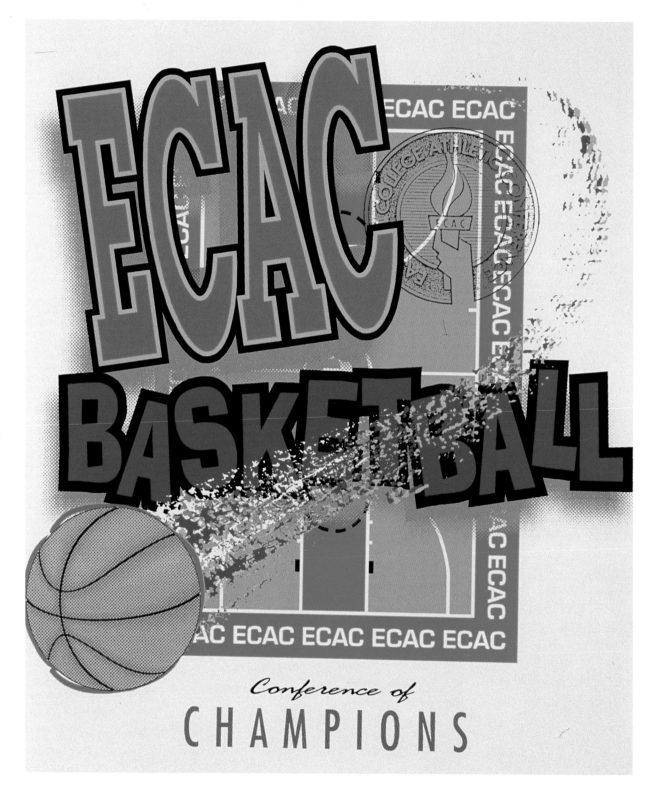

ILLUSTRATION

119

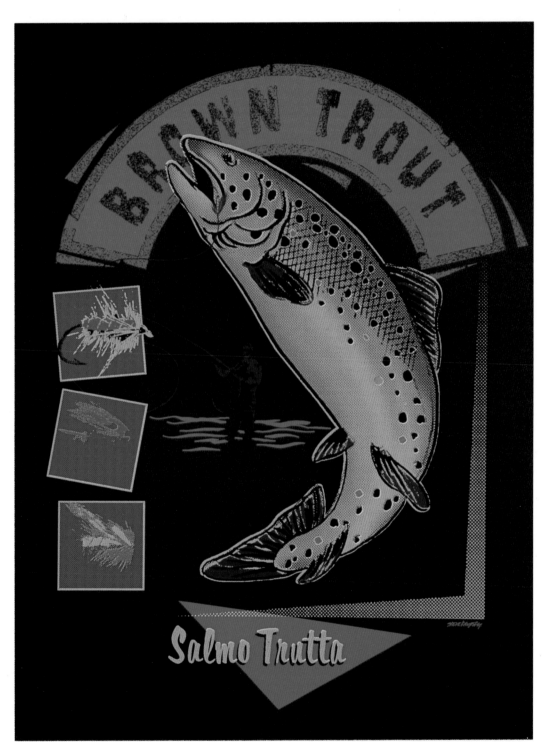

T-Shirt
Design Firm **Steve Krupsky Design**
All Design **Steve Krupsky**
Client **Bach Designs, Ltd**
Software **Aldus FreeHand, Adobe Photoshop, Adobe Illustrator**
Hardware **Macintosh Quadra 650**

The line art for the fish was drawn with a brush pen, streamlined, cleaned up in Illustrator, and brought into FreeHand files. Textures were created in Photoshop and saved as a TIFF.

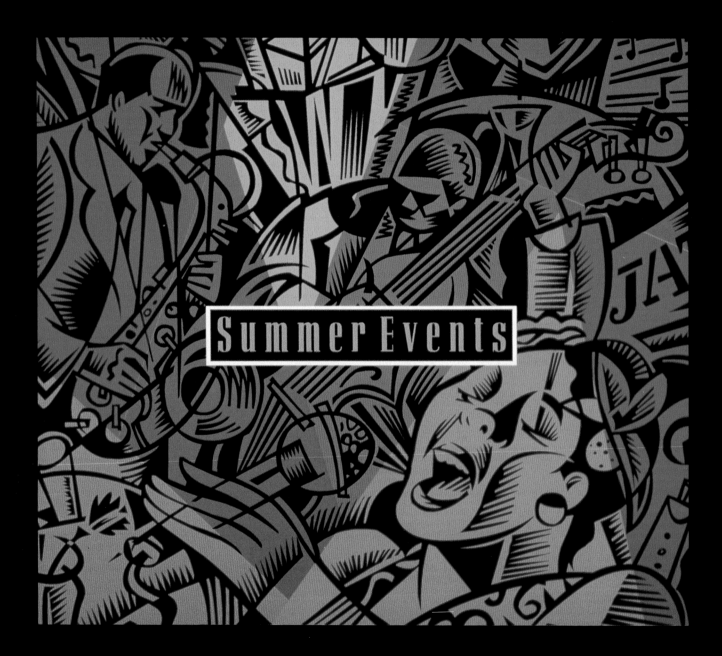

Newsletter Divider Graphic
Design Firm **Mires Design**
Art Director **John Ball**
Designer **Tracy Sabin**
Client **California Center for the Arts, Esondido**
Software **Art Expression**
Hardware **Amiga 2000**

Used as a divider page for a newsletter, this design was cut in
amber film, scanned as a template, and traced in a vector-based
drawing program.

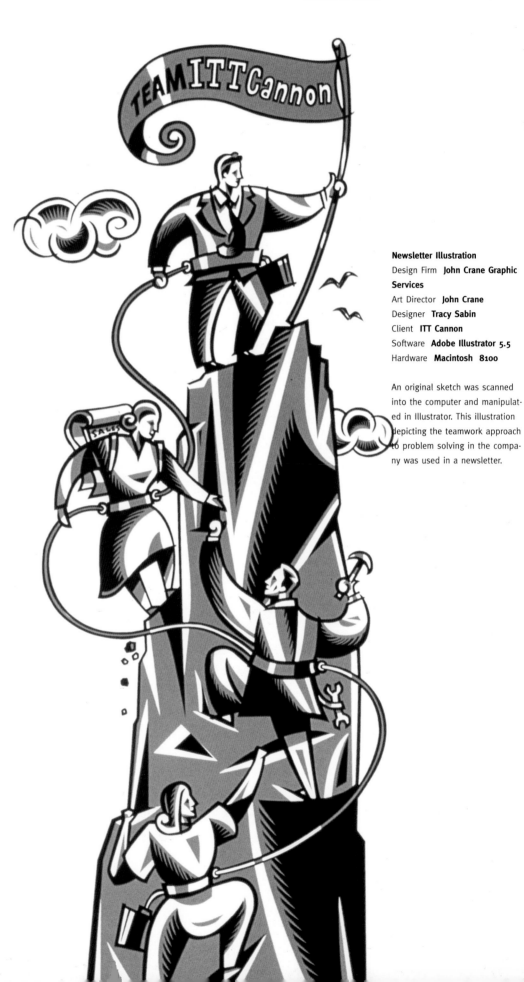

Newsletter Illustration
Design Firm **John Crane Graphic Services**
Art Director **John Crane**
Designer **Tracy Sabin**
Client **ITT Cannon**
Software **Adobe Illustrator 5.5**
Hardware **Macintosh 8100**

An original sketch was scanned into the computer and manipulated in Illustrator. This illustration depicting the teamwork approach to problem solving in the company was used in a newsletter.

122 **Spot Illustrations**
Design Firm **Mires Design**
Art Director **José Serrano**
Designer **Tracy Sabin**
Client **Los Angeles Times**
Software **TV Paint**
Hardware **Amiga 2000**

These illustrations depict historical anecdotes relating to World Cup Soccer events. They ran in a series of special sections of the Los Angeles Times intended for children. The black outlines were cut in amber film and were scanned and colored in a bitmap-based paint program.

Brochure Illustrations
Design Firm **Mires Design**
Art Director **John Ball**
Designer **Tracy Sabin**
Client **Intel**
Software **Art Expression**
Hardware **Amiga 2000**

Illustrations for a brochure explaining the use of an Intel i960 processor and Intel memory in a cellular base station. A pencil sketch was scanned as a template and traced in a vector-based drawing program.

ILLUSTRATION

123

Spot Illustration
Design Firm **Mires Design**
Art Director **Jeff Payne**
Designer **Tracy Sabin Designer**
Client **Airtouch Cellular**
Software **TV Paint**
Hardware **Amiga 2000**

These spot illustrations were used in a facilities brochure. The black outlines were cut in amber, copied through a sheet of tracing paper to add texture, and scanned and painted in TV Paint.

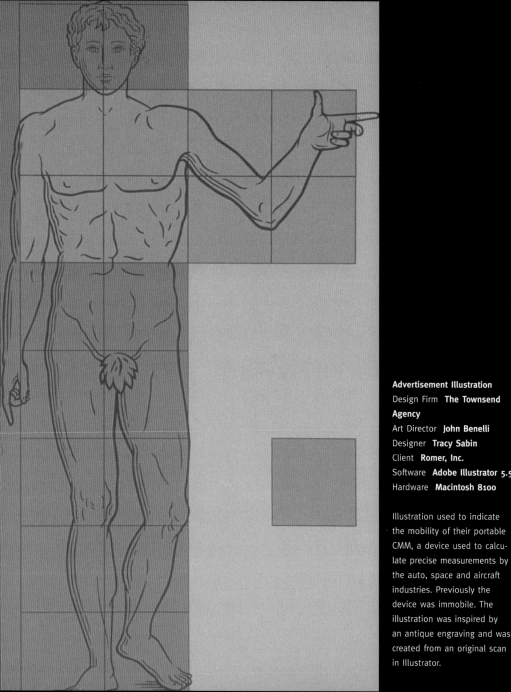

Advertisement Illustration
Design Firm **The Townsend**
Agency
Art Director **John Benelli**
Designer **Tracy Sabin**
Client **Romer, Inc.**
Software **Adobe Illustrator 5.5**
Hardware **Macintosh 8100**

Illustration used to indicate
the mobility of their portable
CMM, a device used to calcu-
late precise measurements by
the auto, space and aircraft
industries. Previously the
device was immobile. The
illustration was inspired by
an antique engraving and was
created from an original scan
in Illustrator.

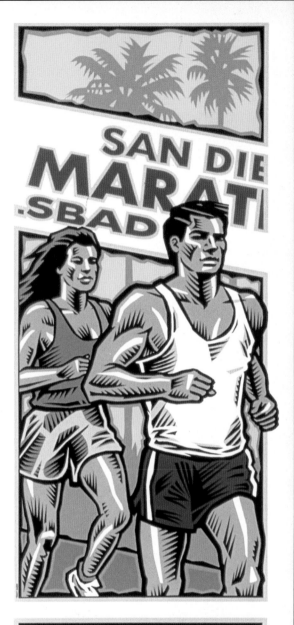

Poster
Design Firm **Tracy Sabin Graphic Design**
Art Director **Lynn Flannigan**
Designer **Tracy Sabin**
Client **InMotion, Inc.**
Software **Adobe Illustrator 5.5**
Hardware **Macintosh 8100**

The poster promoting the 1995 San Diego marathon was created from a pencil sketch used as a template in Illustrator.

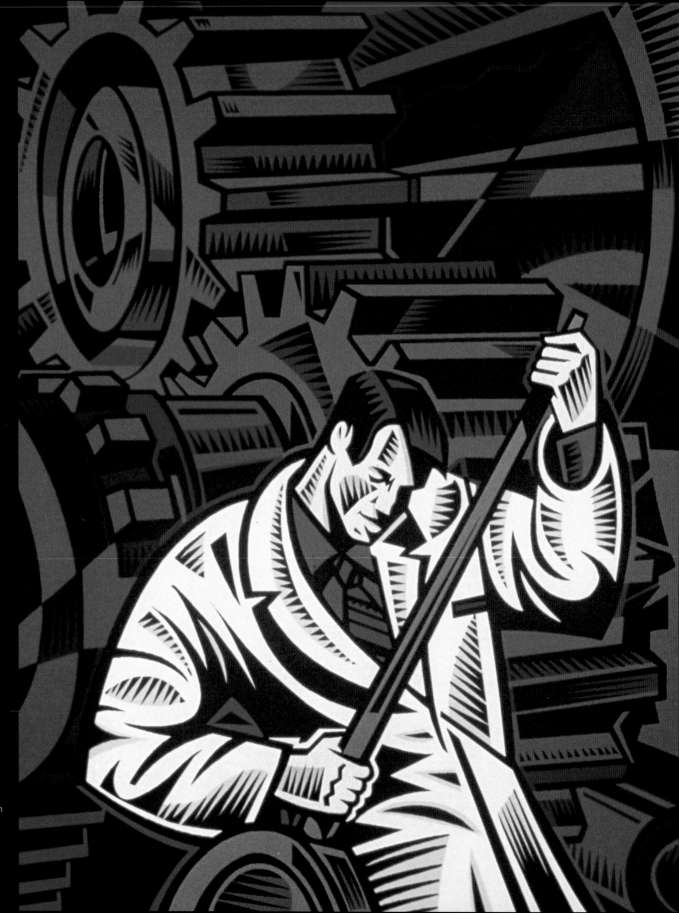

Illustration
Design Firm **Carol Kerr
Graphic Design**
Art Director **Eve Morris**
Designer **Tracy Sabin**
Client **American Healthcare
Systems**
Software **Art Expression**
Hardware **Amiga 2000**

This illustration appeared in
an annual report with the
theme of integrated services in
the healthcare environment. A
pencil drawing was used as a
template in this design.

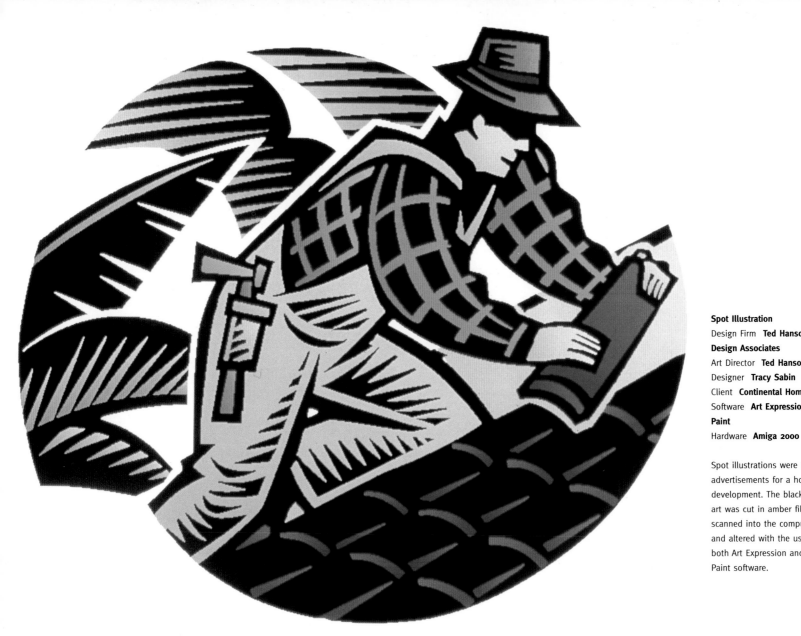

Spot Illustration
Design Firm **Ted Hanson**
Design Associates
Art Director **Ted Hanson**
Designer **Tracy Sabin**
Client **Continental Homes**
Software **Art Expression, TV
Paint**
Hardware **Amiga 2000**

Spot illustrations were used as advertisements for a housing development. The black line art was cut in amber film, scanned into the computer and altered with the use of both Art Expression and TV Paint software.

Brochure Cover
Design Firm **Lia & Company**
Art Director **Lia Scardamaglia**
Designer **Tracy Sabin**
Client **Hewlett-Packard**
Software **Adobe Illustrator 5.5**
Hardware **Macintosh 8100**

This cover illustration was developed for a brochure which explains Hewlett-Packard's factory on-call services designed for resellers and volume customers. The design was created in Illustrator from an original pencil drawing.

Book Series Illustration
Design Firm **Mires Design**
Art Director **Scott Mires**
Designer **Tracy Sabin**
Client **Harcourt Brace Jovanovich**
Software **Art Expression**
Hardware **Amiga 2000**

The original illustration was
cut in amber film and pre-
pared through traditional
means. The designer scanned
the original and traced it in a
vector-based drawing program.

ILLUSTRATION

129

Housing Development Logo
Design Firm **Mires Design**
Art Director **Scott Mires**
Designer **Tracy Sabin**
Client **McMillin Communities**
Software **Art Expression**
Hardware **Amiga 2000**

The original illustration for this
housing development logo was
cut in amber film, Xeroxed,
and colored with colored pen-
cils. This image was scanned
and reworked in Art
Expression.

130 **Self-Promotional Illustration**
Design Firm **Beth Santos**
Design
All Design **Beth Santos**
Software **Adobe Photoshop**
Hardware **Macintosh Quadra**
650

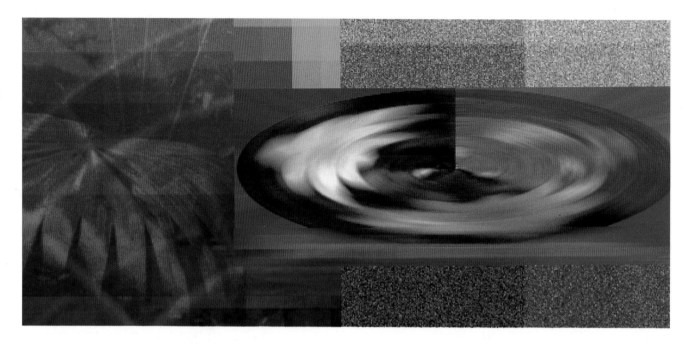

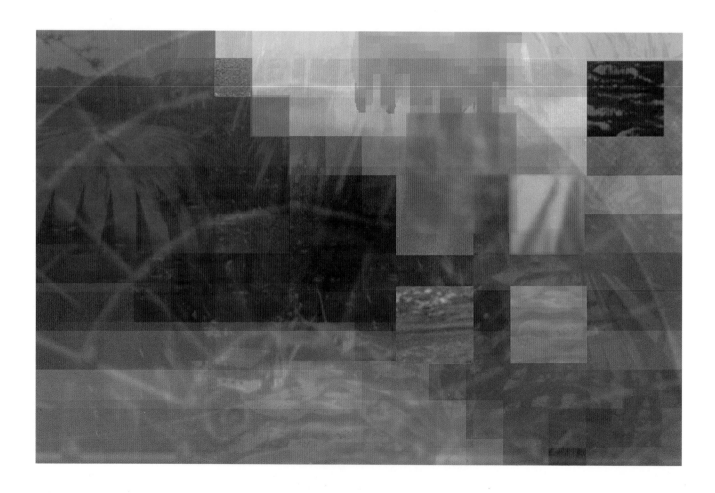

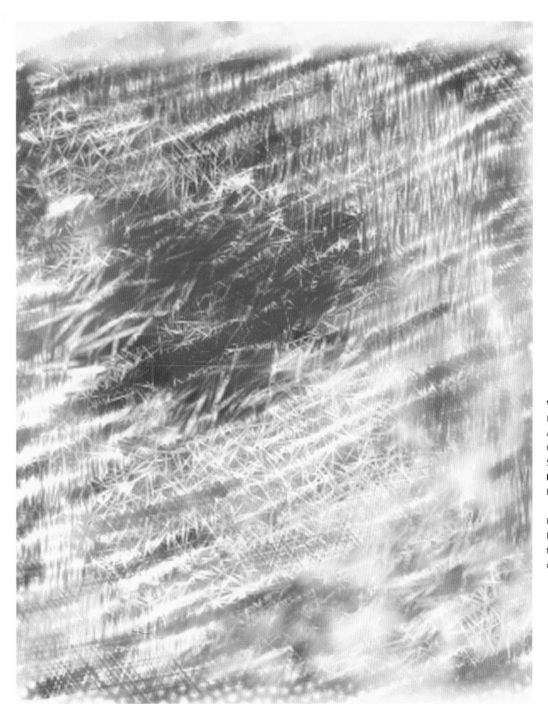

Valentine's Day Card
Design Firm **Imagewright**
All Design **Annie Higbee**
Client **Self-promotion**
Software **Fractal Design Painter**
Hardware **Macintosh**

Using various patterns in Painter, the designer created this card with various colors on the computer.

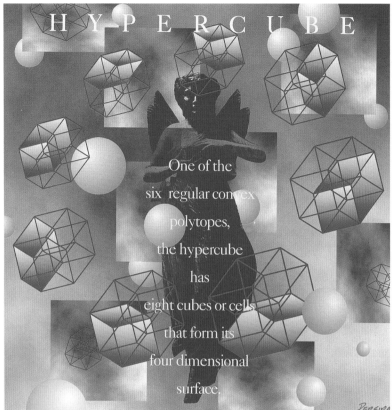

Hypercube

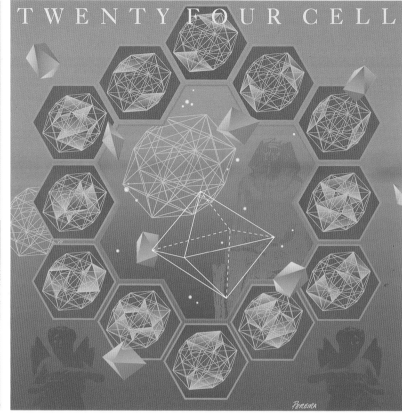

Twenty Four Cell

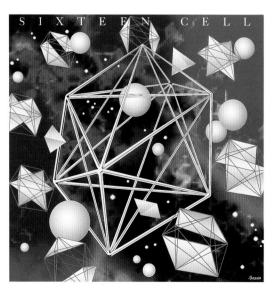

Sixteen Cell

Design Firm **Eduino J. Pereira Graphic Design**
Designer **Eduino J. Pereira**
Client **Self-promotion**
Software **CorelDraw 4.0**
Hardware **386 PC**

These pieces were created entirely in CorelDraw with the exception of the imported angel image. The angel was scanned from a nineteenth century engraving (public domain). The background skyscape was created using CorelDraw post-script background fills.

The eight floating geometric renderings depict a series of "hypercubes". These are representations of a four-dimensional geometric shape, known as a "polytope," containing eight cubes on its surface. Each of the eight renderings highlights a cube which forms part of the surface of the hypercube.

ILLUSTRATION

133

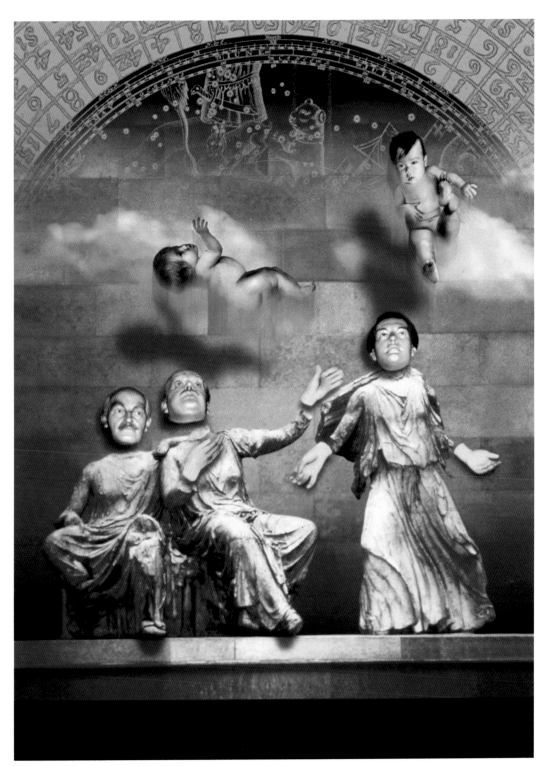

Promotional Illustration
Design Firm **EB Graphics**
Designer **Elaine Benson**
Client **Self-promotion**
Software **Adobe Photoshop
2.5.1**
Hardware **Macintosh Quadra
950, HP color scanner**

134

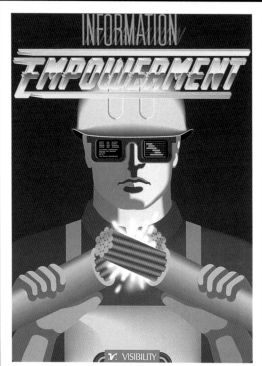

Promotional Posters
Design Firm **James Potocki**
Communications
All Design **James Potocki**
Client **Visibility**
Software **Adobe Illustrator,**
Adobe Photoshop
Hardware **Macintosh**

The original artwork for this
piece was conceived with
markers while the later,
mechanical artwork was
accomplished with Illustrator
and Photoshop.

136

Magazine Advertisement
Design Firm **Metamorfo**
Art Director **Mats Persson**
Designer **Philip Nicholson**
Client **Pioneer, Sweden**
Software **Adobe Illustrator,
Adobe Dimensions, Adobe
Photoshop**
Hardware **Macintosh Quadra
950**

Most people think this is a
photo, but it's not. The
wood was generated sepa-
rately, the radio was pushed
into the wood using a custom
"displacement map" in
Photoshop, and the controls
and graphics were generated
in Illustrator and Dimensions
and placed in the Photoshop
file.

Personal Art
Design Firm **Philip Nicholson**
All Design **Philip Nicholson**
Client **Self-promotion**
Software **Adobe Illustrator,
Adobe Dimensions, Adobe
Photoshop**
Hardware **Macintosh Quadra
950**

This rock image began as a
one-inch piece of granite then
scanned into the computer
with a flatbed scanner. It was
then given shape using
Photoshop's "dodge" and
"burn" tools, before the radio
was added.

ILLUSTRATION

137

Product Brochure Illustration
Design Firm **Axelsson & Co**
Art Director **Robert Kirtley**
Designer **Philip Nicholson**
Client **DIAB**
Software **Adobe Illustrator,**
Adobe Dimensions, Adobe
Photoshop, Strata StudioPro
Hardware **Macintosh Quadra**
950

The foil was modeled in
StudioPro with use of a dia-
mond pattern bump map.
The graphics were taken from
Illustrator and Dimensions,
and the bottle and ribbon
were drawn and painted in
Illustrator and Photoshop.

Product Illustration
Design Firm **Axelsson & Co**
Art Director **Mats Nilsson**
Designer **Philip Nicholson**
Client **Saab-Scania Combitech**
Electronics
Software **Adobe Illustrator,**
Adobe Dimensions, Adobe
Photoshop, Fractal Design
Painter
Hardware **Macintosh Quadra**
950

This image was drawn in
Illustrator and Dimensions and
was painted in Photoshop and
Painter.

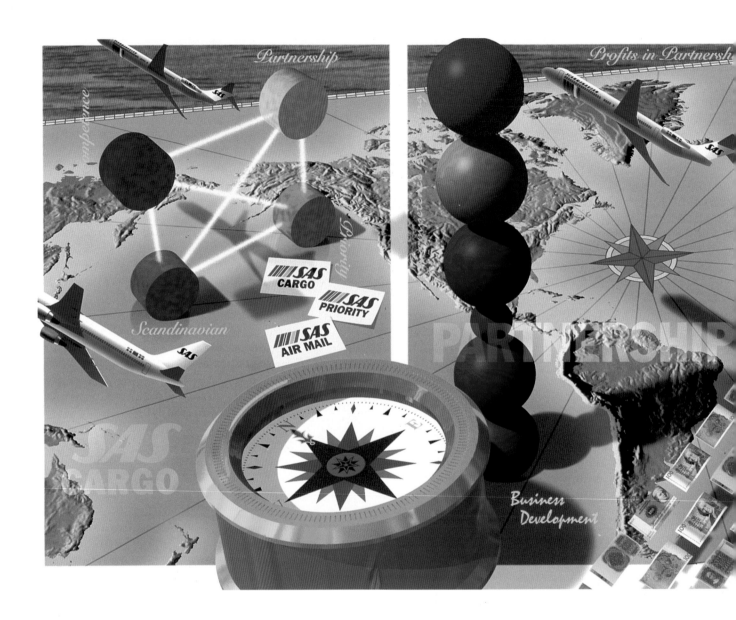

Poster Series
Design Firm **Pyramid Communications**
Art Director **Roland Olsson**
Designer **Philip Nicholson**
Client **Sas Cargo**
Software **Adobe Illustrator, Adobe Dimensions, Adobe Photoshop, Strata StudioPro**
Hardware **Macintosh Quadra 950**

At full size, this file is over 220 MB (RGB). All items were drawn separately and assembled in Photoshop, one poster at a time. The Guide drawing for this was put together in Dimensions. The individual items were drawn in Illustrator, Dimensions, Photoshop, and StudioPro.

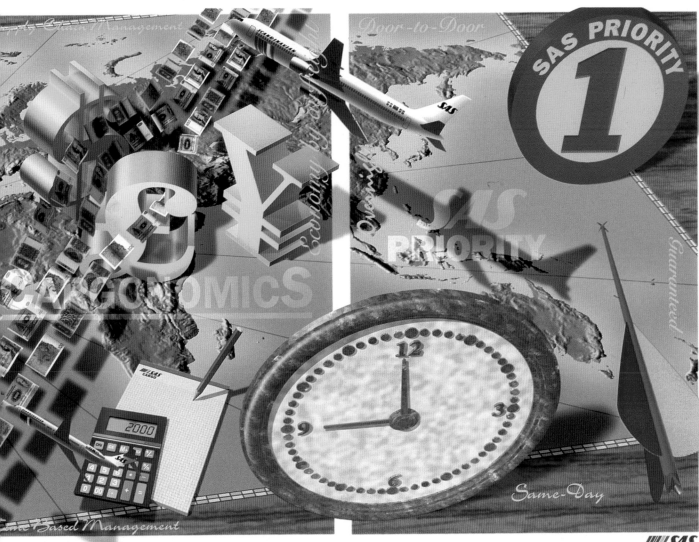

Poster
Design Firm **Stocks, Austin, Sythe**
Art Director **Nick Austin**
Designer **Philip Nicholson**
Client **British Telecom**
Software **Adobe Illustrator, Adobe Dimensions, Adobe Photoshop**
Hardware **Macintosh Quadra 950**

The designer combined original typography with computer-generated, three-dimensional illustrations for this design.

ILLUSTRATION

141

Brochure Illustrations
Design Firm **Pyramid Communications**
Art Director **Rune Osberg**
Designer **Philip Nicholson**
Client **Tour & Anderson**
Software **Adobe Illustrator, Strata StudioPro, KPT Bryce**
Hardware **Power Macintosh 8100/110**

This high-tech cartoon character was created in StudioPro so it would be possible to use the illustration in various promotions.

Product Brochure Illustration
Design Firm **Axelsson & Co**
Art Director **Robert Kirtley**
Designer **Philip Nicholson**
Client **DIAB**
Software **Adobe Illustrator, Adobe Dimensions, Adobe Photoshop, Strata StudioPro**
Hardware **Macintosh Quadra 950**

The foil was modeled in StudioPro with use of a diamond pattern bump map. The graphics were taken from Illustrator and Dimensions, and the bottle and ribbon were drawn and painted in Illustrator and Photoshop.

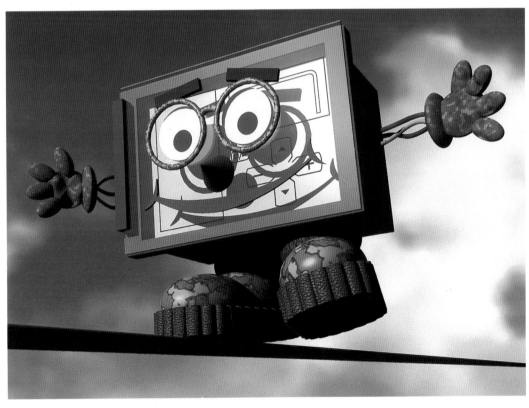

142

Curry Powder Illustration
Design Firm **David Taylor Associates**
Art Director **Annette Scarfe**
Designer **Philip Nicholson**
Client **Jamaica Best**
Software **Adobe Illustrator, Adobe Photoshop, Strata StudioPro**
Hardware **Power Macintosh 8100/110**

The pots and jugs were modeled in StudioPro, and the food and herbs were drawn in Illustrator and painted in Photoshop. Photoshop's "layers" function was very useful in adding dimension to this composition.

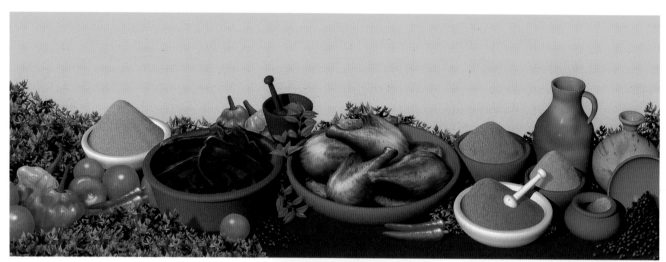

Latex Abstractions
Design Firm **Robin Lipner Digital**
All Design **Robin Lipner**
Client **Self-promotion**
Software **Adobe Photoshop**
Hardware **Macintosh Quadra 840 AV, UMAX Scanner**

The designer created this image by scanning objects directly on the scanner bed and pasting and distorting them in Photoshop.

ILLUSTRATION

143

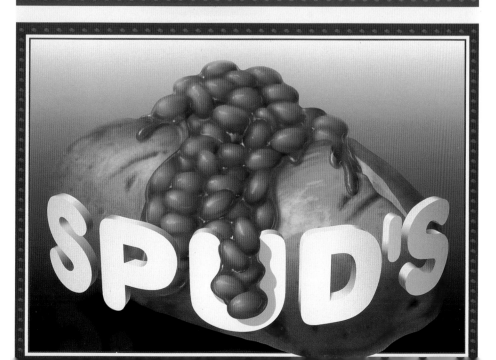

Poster Series
Design Firm **David Nadel Communications**
Art Director **Jeff Jessop**
Designer **Philip Nicholson**
Client **Fairfield Catering Company**
Software **Adobe Illustrator, Adobe Dimensions, Adobe Photoshop, Fractal Design Painter, KPT Bryce**
Hardware **Macintosh Quadra 950**

The sea in this image makes use of Painter's glass distortion filter and a custom paper grain that was the same as the water. The palm fronds are filled with a radial blend from KPT Bryce, and the rest is drawn in Illustrator and Dimensions and painted in Photoshop.

Holidays
Design Firm **Robin Lipner Digital**
All Design **Robin Lipner**
Client **Self-promotion**
Software **Alias Studio**
Hardware **Silicon Graphics**

All elements were created with three-dimensional effects on the computer. The only images taken from photographs are the pine background and the designer's reflection in the ornament.

Duck Season
Design Firm **Robin Lipner Digital**
All Design **Robin Lipner**
Client **Self-promotion**
Software **Infini D, Adobe Photoshop**
Hardware **Macintosh Quadra 840 AV**

For this illustration, the designer imported plot files of photographs to develop texture maps.

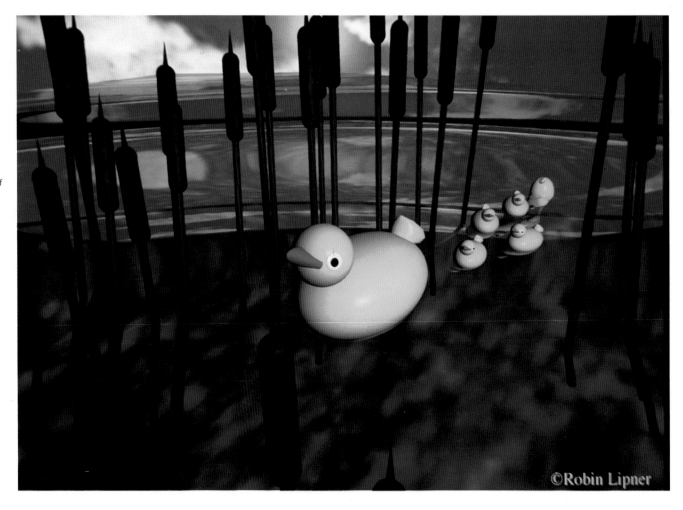

©Robin Lipner

ILLUSTRATION

145

Jazz
Design Firm **Robin Lipner**
Digital
All Design **Robin Lipner**
Client **Self-promotion**
Software **Alias Power**
Animator
Hardware **Silicon Graphics**

All of the elements of this promotional illustration were created with three-dimensional effects except for the photograph outside of the window.

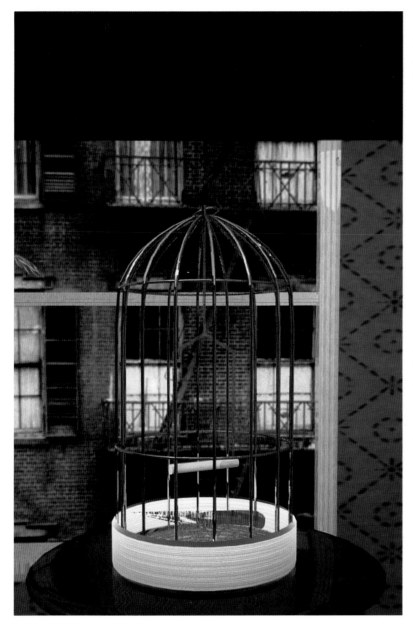

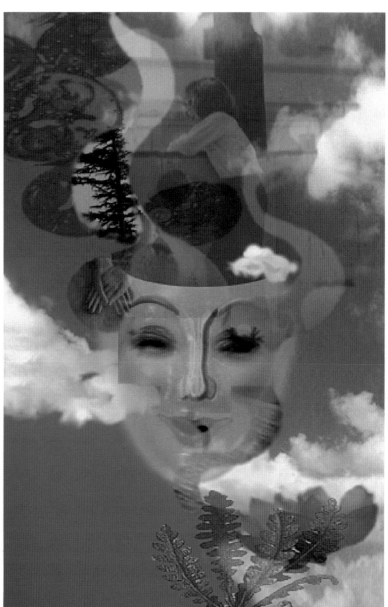

Scent
Design Firm **Robin Lipner**
Digital
All Design **Robin Lipner**
Client **Self-promotion**
Software **Adobe Photoshop**
Hardware **Macintosh Quadra 840 AV, UMAX Scanner**

The Mardi gras mask in this image was taken from video frame that captures the face.

146

Love Life
Design Firm **Robin Lipner Digital**
All Design **Robin Lipner**
Client **Self-promotion**
Software **Adobe Photoshop, Adobe Illustrator**
Hardware **Macintosh Quadra 840 AV, UMAX Scanner**

Peppers
Design Firm **Robin Lipner Digital**
All Design **Robin Lipner**
Client **Self-promotion**
Software **Adobe Photoshop, Adobe Illustrator**
Hardware **Macintosh Quadra 840 AV, UMAX Scanner**

Free Associate
Design Firm **Robin Lipner Digital**
All Design **Robin Lipner**
Client **Self-promotion**
Software **Adobe Photoshop, Adobe Illustrator**
Hardware **Macintosh Quadra 840 AV, UMAX Scanner**

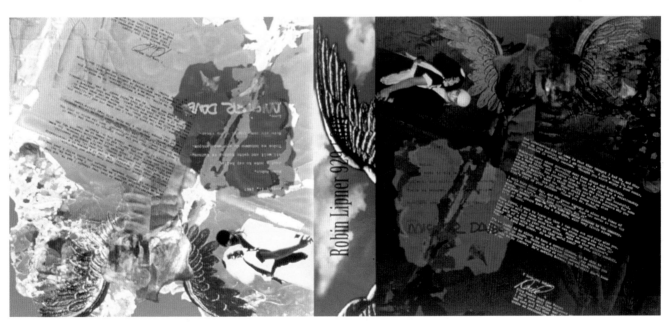

Bye Dave
Design Firm **Robin Lipner Digital**
All Design **Robin Lipner**
Client **Self-promotion**
Software **Adobe Photoshop, Adobe Illustrator**
Hardware **Macintosh Quadra 840 AV, UMAX Scanner**

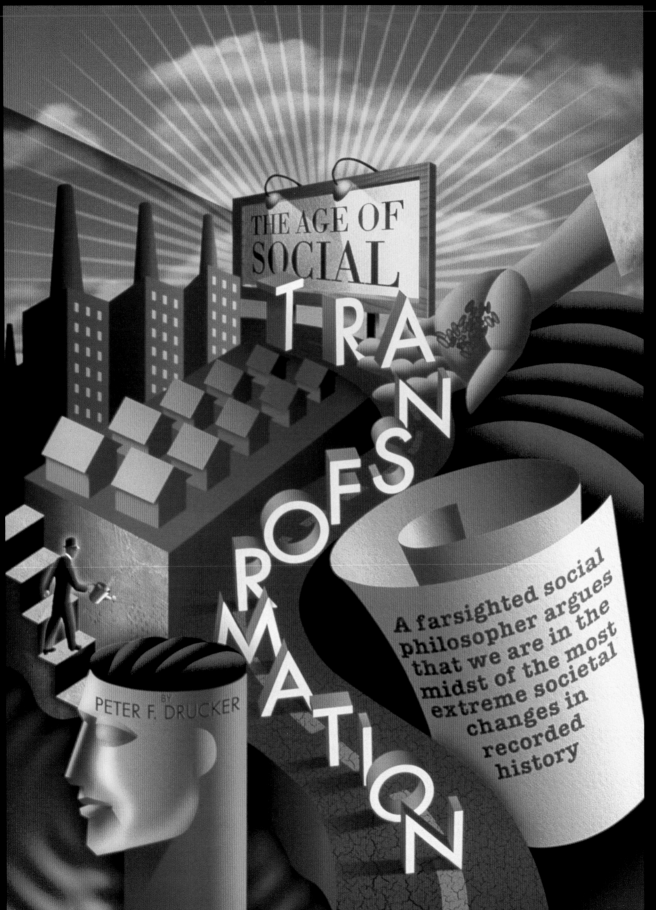

**Magazine Cover,
Interior Illustrations**
Design Firm **Studio M D**
Art Director **Judy Garlan,
Atlantic Monthly**
Illustrator **Glenn Mitsui,
Studio M D**
Client **Atlantic Monthly
Magazine**
Software **Adobe Photoshop,
Fractal Design Painter, Adobe
Illustrator**
Hardware **Macintosh IIcx
(Enhanced)**

The cover and inside spread
illustrations for an Atlantic
Monthly Magazine issue began
as original sketches that were
refined and scanned into the
computer. The designer
brought the images into
FreeHand as black and white
line drawings. The file was
saved as an Illustrator file and
imported into Photoshop
where it was made into a
channel. Using the "path"
tool, he segmented out the
image and rendered it with
color and texture.

ILLUSTRATION

151

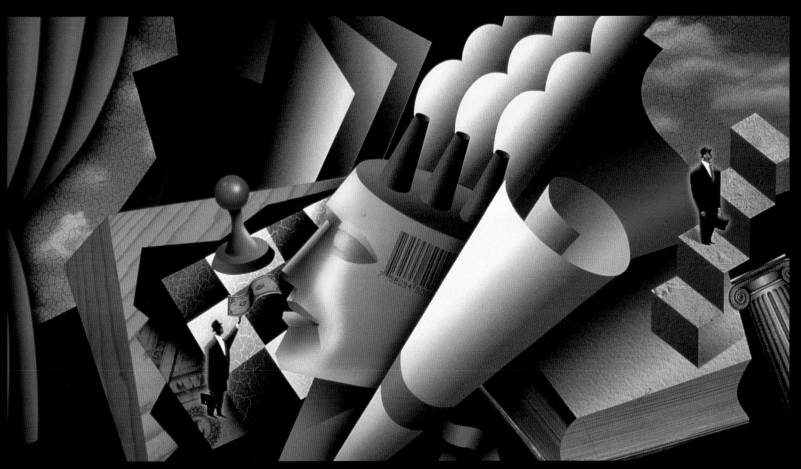

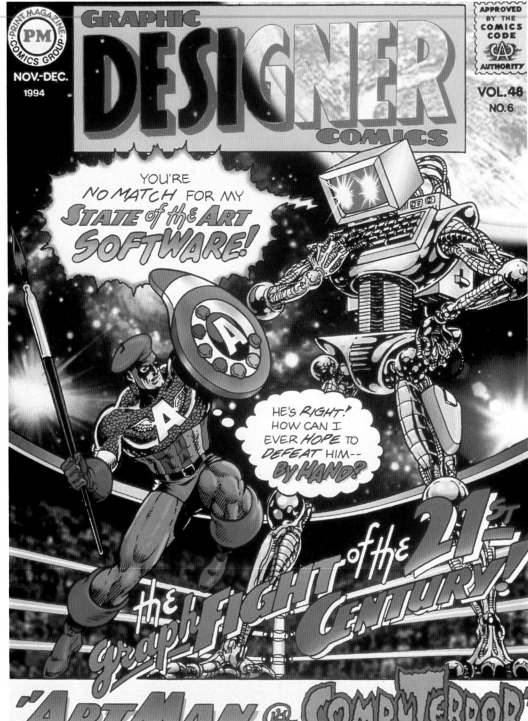

Video Box Cover
Design Firm **The Dynamic Duo, Inc.**
Art Director **Leslie Lemberg**
Designer **Arlen Schumer**
Client **Physicians' Online**
Software **Adobe Photoshop**
Hardware **Apple Power Macintosh PC 8100, Wacom Stylus**

For the background, the designer scanned in an actual computer circuit board and "titled" it in Perspective using Photoshop. All other art was black and white line art that was scanned in and colored using Photoshop.

Magazine Illustration
Design Firm **The Dynamic Duo, Inc.**
Art Director **Andrew Kner**
Designer **Arlen Schumer**
Client **Print Magazine**
Software **Adobe Photoshop**
Hardware **IBM 486/33, Wacom Stylus**

For special parody issue of Print Magazine predicting what the coming millennium's impact will be on graphic design and illustration, the designers wrote and illustrated this four-page story. All black and white line art was scanned in and colored using Adobe Photoshop. Photographs of planets, crowd scones, and outer space were also scanned in and added to the image.

ILLUSTRATION

153

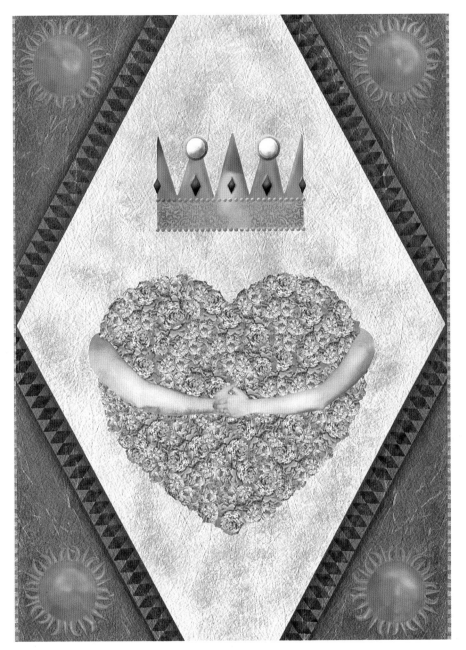

Illustration
Designer **Nicole Crameri Raynard**
Software **Adobe Photoshop 3.0, Fractal Design Painter**
Hardware **Macintosh Quadra 950, 68M RAM**

Entire image was created on the Macintosh except for the photos of arms and flowers. Seamless textures were created in Photoshop and applied in Painter.

Postcard
Design Firm **AVX Design**
Designer **Cynthia Satloff**
Software **Fractal Design Painter 3.0, Adobe Photoshop 2.5**
Hardware **Macintosh Quadra 950**

This design was developed with the "airbrush" and "pen" tools in Fractal Design Painter.

154

Advertisement Illustration
Designer **Diane Fenster**
Advertising Agency **Levy and Wurz Channel Marketing**
Art Director **David Levy**
Client **IBM**
Software **Adobe Photoshop 3.0**
Hardware **Macintosh Quadra 840 AV**

The leaves in this design were actual autumn leaves placed on the scanner and arranged in Photoshop on three separate layers. Both the bark and the large piece of rusted metal used for the background were also scanned directly into the computer.

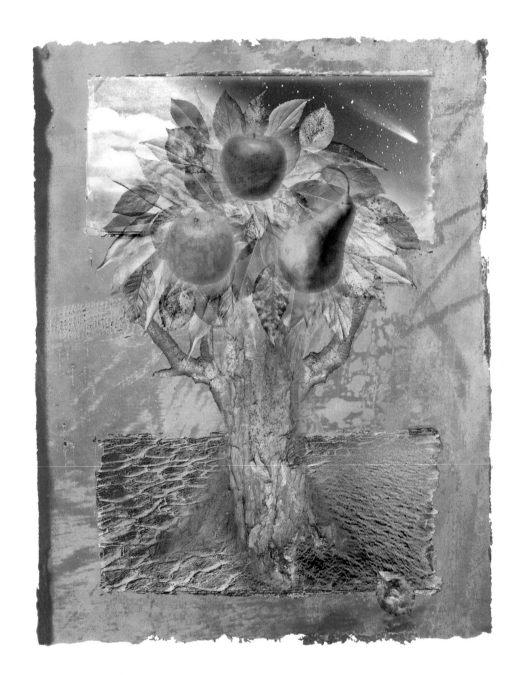

ILLUSTRATION

155

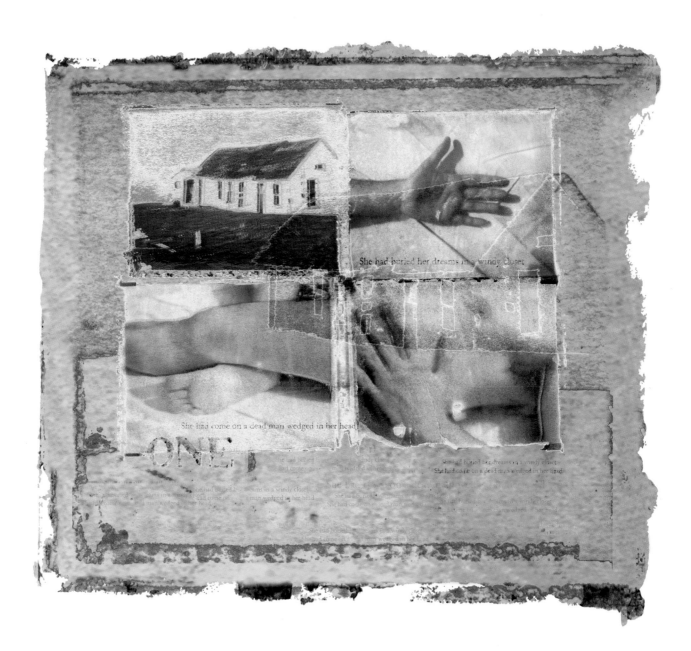

Fine Art Series
Designer **Diane Fenster**
Software **Adobe Photoshop 3.0**
Hardware **Macintosh Quadra**
840 AV

156

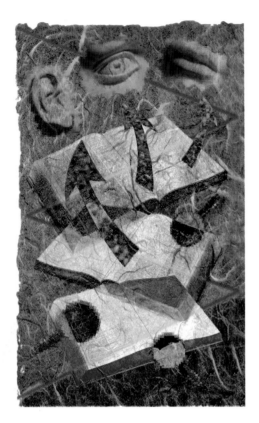

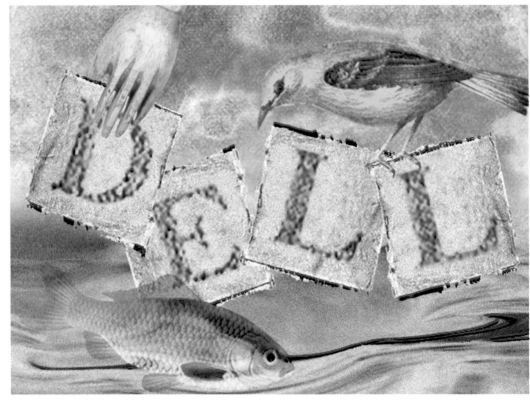

Magazine Cover
Designer **Diane Fenster**
Client **Apple**
Software **Adobe Photoshop 3.0**
Hardware **Macintosh Quadra 840 AV**

The background was taken from a scan of rice paper. The zig-zag line was drawn with the "path" tool and then stroked using "dissolve" mode. The interesting color interplays were a result of placing objects on layers assigned to the "difference" mode.

Advertisement Illustration
Designer **Diane Fenster**
Ad Agency **Goldberg Moser O'Neill**
Art Director **Mike Moser**
Client **Dell Computers**
Software **Adobe Photoshop 3.0, Adobe Dimensions 2.0, Kai's Power Tools 2.0**
Hardware **Macintosh Quadra 840 AV**

Spheres in the image were created by placing a letter on a pattern background in Photoshop, using "marquee" to select a circular area, and then applying Kai's filter "glass lens soft." Type was created in Dimensions, and the texture was applied using both Photoshop and Kai's Texture Explorer.

ILLUSTRATION

157

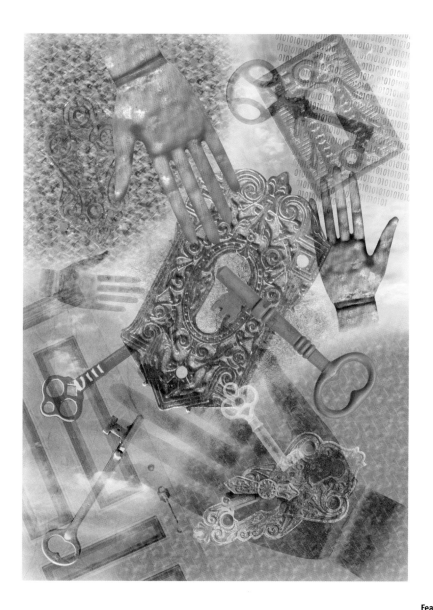

Feature Illustration
Designer **Diane Fenster**
Art Director **Brian Day**
Client **Ziff Davis, Germany**
Software **Adobe Photoshop
3.0, Specular TextureScape**
Hardware **Macintosh Quadra
840 AV**

All of the three-dimensional
objects, such as the hand,
keys, and keyholes, were
placed directly on a scanner
and manipulated in
Photoshop.

Catalog Cover
Designer **Diane Fenster**
Art Director **Michael Zipkin
(Cardinal Music Publishing)**
Client **Cardinal Music
Publishing**
Software **Adobe Photoshop
3.0, Aldus FreeHand**
Hardware **Macintosh Quadra
840 AV**

For this cover, the designer
used black and white and
color scanned photos, xerox-
es, schematics, and Photo CD
images. The hand image was
a frame from a video, and the
masthead was provided as a
FreeHand EPS. The compiled
design was rasterized in
Photoshop.

158

Design Firm Directory

760 Associates
36 Lansing Road
West Newton, MA 02165

Ampersand Design Group
7575 N.W. 50th Street
Miami, FL 33166

Animus Communicaáto
Ladeira Do Ascurra 115A
Brazil

AVX Design
14 Cady Street
Providence, RI 02903

Bach Design Ltd.
400 Bridge Street
Salem, MA 01970

Robert Bailey Incorporated
0121 S.W. Bancroft Street
Portland, OR 97201

Blink
1656 Grove Street
San Francisco, CA 94117

John Crane Graphic Services
2522 Chambers Road
Suite 214 E
Tustin, CA 92680

Creative Company Inc.
3276 Commercial Street S.E.,
Suite 200
Salem, OR 97302-4596

Richard Danne & Associates
126 Fifth Avenue
New York, NY 10011

dD Graphics
44 Queens Street
Rochester, NY 14609

The Design Company
One Baltimore Place, Suite 170
Atlanta, GA 30308

The Dynamic Duo, Inc.
95 Kings Highway S.
Westport, CT 06880

EB Graphics
P.O. Box 1418
Cupertino, CA 95015-1418

Electronic Arts
1450 Fashion Island
Boulevard
San Mateo, CA 94404

Eyebeam
2500 Gateway Centre
Boulevard, Suite 600
Morrisville, NC 27560

Franklin Stoorza
225 Broadway, Suite 1600
San Diego, CA 92101

Ted Hanson Design
Associates
1955 4th Avenue
San Diego, CA 92101

Hornall Anderson
Design Works
1008 Western
Suite 600
Seattle, WA 98104

IDG (HK) Communication
701-5 Kam Chung Building
54 Jaffz Road
Wanchai Hong Kong

Imagewright
P.O. Box 914
Rockport, ME 04856

Peat Jariya Design
1210 W. Clay Suite 13
Houston, TX 77019

Kollberg/Johnson Associates
7 W. 18th
New York, NY 10011

Carol Kerr Graphic Design
1423 Elevation Road
San Diego, CA 92110

Steve Krupsky Design
31 Livingstone Avenue
Beverly, MA 01915

Jim Lange Design
203 N. Wabash #1312
Chicago, IL 60601

Price Learman Associates
737 Market Street
Kirkland, WA 98033

Lia & Company
89 1/2 Chester Road
Derry, New Hampshire 03038

Robin Lipner Digital
220 W. 21st Street, 2E
New York, NY 10011

McGlothlin Associates, Inc.
5397 Twin Knolls Road, #18
Columbia, MD 21045

Mires Design
2345 Kettner Boulevard
San Diego, CA 92101

Modelhart Grafik-Design
Inp.-Ludwig-Pechstr. 1
A-5600 St. Johann/Pg.
Austria

Monroy & Cover Design
31 Hodges Alley
San Francisco, CA 94133

Steven Morris Design
10284 Royal Ann Avenue
San Diego, CA 92126

Philip Nicholson
Illustrations AB
Segelvägen 34
432 75 Träslövsläge
Sweden

Northlich Stolley LaWarre
Design Group
200 W. Fourth Street
Cincinnati, OH 45202

Parker Brothers
50 Dunham Road
Beverly, MA 01915

Eduino J. Pereira,
Graphic Design
10837-F Amherst Avenue
Wheaton, MD 20902

Peterson & Company
2200 North Lamar, Suite 310
Dallas, TX 75202

James Potocki
Communications
1634 Ponce de Leon Avenue
#103
Atlanta, GA 30307

Rapp Collins Communications
901 Marquette Avenue S.,
17th Floor
Minneapolis, MN 55432

Reiser & Reiser Advertising
and Marketing
4201 Salzedo Street
Coral Gables, FL 33146

The Riordon Design
Group Inc.
1001 Queen Street W.
Mississaucua
Ontario L5H 4E1 Canada

Martin Ross Design
1125 Xerxes Avenue S.
Minneapolis, MN 55405

Tracy Sabin Graphic Design
13476 Ridley Road
San Diego, CA 92129

Mike Salisbury
Communications
2200 Amapola Court
Torrance, CA 90501

Beth Santos Design
2 Village Hill Lane
Natick, MA 01760

Clifford Selbert Design
Collaborative
2067 Massachusetts Avenue
Cambridge, MA 02140

Sophisticated Dog
Design Group
676 E. 25th Street
Paterson, NJ 07504

Shimokochi/Reeves
4465 Wilshire Boulevard
Los Angeles, CA 90010

Studio M D
1512 Alaskan Way
Seattle, WA 98101

The Townsend Agency
6640 Lusk Boulevard
Suite 202
San Diego, CA 92121

Veronica Graphic Design
Suite 67 Isle of Capri
Commercial Centre
Queensland 4217
Australia

Elton Ward Design
P.O. Box 802
Parramatta
NSW 2124
Australia

Watt, Roop & Co.
1100 Superior Avenue
Cleveland, OH 44114

Wolfram Research
Publications Department
100 Trade Center Drive
Champaign, IL 61820

Zubi Design
57 Norman Avenue #4R
Brooklyn, NY 11222

Designer Directory

Jack Anderson
Hornall Anderson
Design Works
1008 Western, Suite #600
Seattle, WA 98104

John Anicker
Hornall Anderson
Design Works
1008 Western, Suite #600
Seattle, WA 98104

Kristen Balouch
Zubi Design
57 Norman Avenue #4R
Brooklyn, NY 11222

Omid Balouch
Zubi Design
57 Norman Avenue #4R
Brooklyn, NY 11222

David Bates
Hornall Anderson
Design Works
1008 Western, Suite #600
Seattle, WA 98104

Ellen Bednarek
Robert Bailey Incorporated
0121 S.W. Bancroft Street
Portland, OR 97201

Elaine Benson
EB Graphics
P.O. Box 1418
Cupertino, CA 95015-1418

Darlene Benzon
dD Graphics
44 Queens Street
Rochester, NY 14609

Bruce Branson-Meyer
Hornall Anderson Design
Works
1008 Western, Suite #600
Seattle, WA 98104

Jeff Breiderbach
Clifford Selbert Design
Collaborative
2067 Massachusetts Avenue
Cambridge, MA 02140

Ron Brown
Mike Salisbury
Communications
2200 Amapola Court
Torrance, CA 90501

Jill Bustamante
Hornall Anderson
Design Works
1008 Western, Suite #600
Seattle, WA 98104

Greg Carter
Eyebeam
2500 Gateway Centre
Boulevard, Suite #600
Morrisville, NC 27560

Lisa Cerveny
Hornall Anderson
Design Works
1008 Western, Suite #600
Seattle, WA 98104

Cliff Chung
Hornall Anderson
Design Works
1008 Western, Suite #600
Seattle, WA 98104

Gail Cover
Monroy & Cover Design
31 Hodges Alley
San Francisco, CA 94133

Richard Danne
Richard Danne & Associates
126 Fifth Avenue
New York, NY 10011

Paul Dean
604 France Street
Baton Rouge, LA 70802

Chris De Lisen
Elton Ward Design
P.O. Box 802
Parramatta NSW 2124
Australia

David Dixon
Eastern Tennessee State
University
ETSU Department of Art
Box 70708
Johnson City, TN 37614

Jason Dominiak
Elton Ward Design
P.O. Box 802
Parramatta NSW 2124
Australia

Bruce Edwards
Rapp Collins Communications
901 Marquette Avenue S.
17th Floor
Minneapolis, MN 55432

Scott Eggers
Hornall Anderson
Design Works
1008 Western, Suite #600
Seattle, WA 98104

D. Eliason
Peterson & Company
2200 North Lamar, Suite #310
Dallas, TX 75202

Heidi Favour
Hornall Anderson
Design Works
1008 Western, Suite #600
Seattle, WA 98104

Diane Fenster
140 Berendos Avenue
Pacifica, CA 94044

Iesa Figueroa
Clifford Selbert Design
Collaborative
2067 Massachusetts Avenue
Cambridge, MA 02140

Dan Franklin
Robert Bailey Incorporated
0121 S.W. Bancroft Street
Portland, OR 97201

Dan Franklin
Creative Company Inc.
3276 Commercial Street S.E.,
Suite #200
Salem, OR 97302-4596

Meredith Garre
The Riordon Design Group Inc.
1001 Queen Street W.
Mississaucua
Ontarion L5H 4E1 Canada

Laura Gillespie
Northlich Stolley LaWarre
Design Group
200 W. Fourth Street
Cincinnati, OH 45202

Dan Gonztlez
Ampersand Design Group
7575 N.W. 50th Street
Miami, FL 33166

Suzanne Haddon
Hornall Anderson
Design Works
1008 Western, Suite #600
Seattle, WA 98104

Debra Hampton
Hornall Anderson
Design Works
1008 Western, Suite #600
Seattle, WA 98104

Mary Hermes
Hornall Anderson
Design Works
1008 Western, Suite #600
Seattle, WA 98104

Annie Higbee
Imagewright
P.O. Box 914
Rockport, ME 04856

Corey Higgins
1450 Fashio Island Boulevard
San Mateo, CA 94404

John Hornall
Hornall Anderson
Design Works
1008 Western, Suite #600
Seattle, WA 98104

Mary Chin Hutchinson
Hornall Anderson
Design Works
1008 Western, Suite #600
Seattle, WA 98104

Scott Idleman
Blink
1656 Grove Street
San Francisco, CA 94117

Peat Jariya
Peat Jariya Design
1210 W. Clay, Suite #13
Houston, TX 77019

Peter Johnson
Kollberg/Johnson Associates
7 W. 18th Street
New York, NY 10011

Julie Keenan
Hornall Anderson
Design Works
1008 Western, Suite #600
Seattle, WA 98104

Chuck Klein
Ampersand Design Group
7575 N.W. 50th Street
Miami, FL 33166

Steve Krupsky
Steve Krupsky Design
31 Livingstone Avenue
Beverly, MA 01915

Eric Lam
IDG (HK) Communication Ltd.
701-5 Kam Chung Building
54 Jaffz Road
Wanchai Hong Kong

Jim Lange
Jim Lange Design
203 N. Wabash #1312
Chicago, IL 60601

Julia LaPine
Hornall Anderson
Design Works
1008 Western, Suite #600
Seattle, WA 98104

Robin Lipner
Robin Lipner Digital
220 W. 21st Street, 2E
New York, NY 10011

Julie Lock
Hornall Anderson
Design Works
1008 Western, Suite #600
Seattle, WA 98104

Jennifer Lofgren
Wolfram Research
Publications Department
100 Trade Center Drive
Champaign, IL 61820

Rosanne Lufrano
c/o Harper Collins Publishers
10 E. 53rd Street
New York, NY 10022

Simon Macrae
Elton Ward Design
P.O. Box 802
Parramatta NSW 2124
Australia

Jeff McClard
Hornall Anderson
Design Works
1008 Western, Suite #600
Seattle, WA 98104

Mary Evelyn McGouch
Mike Salisbury
Communications
2200 Amapola Court
Torrance, CA 90501

Gordon McGlothlin
McGlothlin Associates Inc.
5397 Twin Knolls Road #18
Columbia, MD 21045

Fran McKay
The Design Company
One Baltimore Place, Suite #170
Atlanta, GA 30308

Robert Merk
Clifford Selbert Design
Collaborative
2067 Massachusetts Avenue
Cambridge, MA 02140

Glenn Mitsui
Studio M D
1512 Alaskan Way
Seattle, WA 98101

Herbert O. Modelhart
Modelhart Grafik-Design
Inp.-Ludwig-Pechstr. 1
A-5600 St. Johann/Pg.
Austria

Fernando Monroy
Monroy & Cover Design
31 Hodges Alley
San Francisco, CA 94133

Steven Morris
Steven Morris Design
10284 Royal Ann Avenue
San Diego, CA 92126

Ken Morris Jr.
Sophisticated Dog
Design Group
676 E. 25th Street
Paterson, NJ 07504

Darren Namaye
Clifford Selbert Design
Collaborative
2067 Massachusetts Avenue
Cambridge, MA 02140

Lian Ng
Hornall Anderson
Design Works
1008 Western, Suite #600
Seattle, WA 98104

Philip Nicholson
Philip Nicholson Illustrations AB
Segelvägen 34
432 75 Träslövsläge Sweden

Gregory Oznowich
Watt, Roop & Co.
1100 Superior Avenue
Cleveland, OH 44114

Eduino J. Pereira
Eduino J. Pereira Graphic
Design
10837-F Amherst Avenue
Wheaton, MD 20902

Robin Perkins
Clifford Selbert Design
Collaborative
2067 Massachusetts Avenue
Cambridge, MA 02140

B. Peterson
Peterson & Company
2200 North Lamar
Dallas, TX 75202

N.T. Pham
Peterson & Company
2200 North Lamar, Suite #310
Dallas, TX 75202

David Posey
815 Devon Place
Alexandria, VA 22314

James Potocki
James Potocki Communications
1634 Ponce de Leon Avenue
#103
Atlanta, GA 30307

S. Jeffrey Prugh
Watt, Roop & Co.
1100 Superior Avenue
Cleveland, OH 44114

S. Ray
Peterson & Company
2200 North Lamar, Suite #310
Dallas, TX 75202

Leo Raymundo
Hornall Anderson
Design Works
1008 Western, Suite #600
Seattle, WA 98104

Nicole Crameri Raynard
55 St. Paul Street
Brookline, MA 02146

Ross Rezac
Martin Ross Design
1125 Xerxes Avenue S.
Minneapolis, MN 55405

Lynn Riddle
Clifford Selbert Design
Collaborative
2067 Massachusetts Avenue
Cambridge, MA 02140

Shirley Riordon
The Riordon Design Group Inc.
1001 Queen Street W.
Mississaucua
Ontario L5H 4E1 Canada

Marcia Romanuck
The Design Company
One Baltimore Place, Suite #170
Atlanta, GA 30308

Kurt R. Roscoe
Watt, Roop & Co.
1100 Superior Avenue
Cleveland, OH 44114

Tracy Sabin
Tracy Sabin Graphic Design
13476 Ridley Road
San Diego, CA 92129

Mike Salisbury
Mike Salisbury Communications
2200 Amapola Court
Torrance, CA 90501

Beth Santos
Beth Santos Design
2 Village Hill Lane
Natick, MA 01760

Cynthia Satloff
AVX Design
14 Cady Street
Providence, RI 02903

Zina Scarpulla
Harper Collins Publishers
10 E. 53rd Street
New York, NY 10022

Allison Scheel
The Design Company
One Baltimore Place
Suite #170
Atlanta, GA 30308

Andrew Schipp
Elton Ward Design
P.O. Box 802
Parramatta NSW 2124
Australia

Allen Schumer
The Dynamic Duo Inc.
95 Kings Highway S.
Westport, CT 06880

Mamoru Shimokochi
Shimokochi/Reeves
4465 Wilshire Boulevard
Los Angeles, CA 90010

Martin Skoro
Martin Ross Design
1125 Xerxes Avenue S.
Minneapolis, MN 55405

Randy Sowash
650 Sunset Boulevard
Massfield, OH 44907

Sergio Spada
1 Irving Place, P12C
New York, NY 10003

Veronica Tasnadi
Veronica Graphic Design
Suite #67 Isle of Capri
Commercial Centre
Queensland 4217 Australia

Felicío Torres
Animus Comunicação
Ladeira Do Ascurra 115A
Brazil

Ross West
Price Learman Associates
737 Market Street
Kirkland, WA 98033

Dan Wheaton
The Riordon Design
Group Inc.
1001 Queen Street W.
Mississaucua
Ontario L5H 4E1
Canada

Stewart Williams
Creative Company Inc.
3276 Commercial Street S.E.,
Suite #200
Salem, OR 97302-4596

J. Wilson
Peterson & Company
2200 North Lamar, Suite #310
Dallas, TX 75202

160

Design Firm Index

760 Associates **41, 62**

Ampersand Design Group **114, 115, 116, 117**

Animus Comunicação **26, 27**

AVX Design **153**

Bach Design Ltd. **22, 23**

Robert Bailey Incorporated **82, 90**

Blink **10, 11, 12, 15**

John Crane Graphic Services **121**

Creative Company Inc. **82, 91**

Richard Danne & Associates **19**

dD Graphics **77, 78, 79**

The Design Company **103, 104**

The Dynamic Duo, Inc. **152**

EB Graphics **133**

Electronic Arts **105**

Eyebeam **71, 113**

Franklin Stoorza **53**

Ted Hanson Design Associates **127**

Hornall Anderson Design Works **18, 19, 30, 33, 34, 35, 36, 38, 49, 60, 61, 65, 96, 100, 101, 102, 103**

IDG (HK) Communication **108**

Imagewright **67, 70, 71, 107, 131**

Peat Jariya Design **63**

Kollberg/Johnson Associates **81, 86, 87**

Carol Kerr Graphic Design **126**

Steve Krupsky Design **118, 119**

Jim Lange Design **23, 110, 111, 112**

Price Learman Associates **45, 46, 47, 48, 49, 57**

Lia & Company **127**

Robin Lipner Digital **142, 144, 145, 146, 147**

McGlothlin Associates, Inc. **74, 75**

Mires Design **50, 51, 52, 116, 120, 122, 123, 128, 129**

Modelhart Grafik-Design **9**

Monroy & Cover Design **56, 57, 58, 59**

Steven Morris Design **20, 73, 85**

Philip Nicholson Illustrations AB **136, 137, 138, 140, 141, 142, 143**

Northlich Stolley LaWarre Design Group **83**

Parker Brothers **90**

Eduino J. Pereira Graphic Design **132**

Peterson & Company **40, 43**

James Potocki Communications **37, 134**

Rapp Collins Communications **21, 25, 37, 60, 88, 91**

Reiser & Reiser Advertising and Marketing **84**

The Riordon Design Group Inc. **13, 16, 17**

Martin Ross Design **14, 86**

Tracy Sabin Graphic Design **29, 52, 53, 54, 55, 125**

Mike Salisbury Communications **21, 69**

Beth Santos Design **85, 130**

Clifford Selbert Design Collaborative **12, 20, 64**

Sophisticated Dog Design Group **112**

Shimokochi/Reeves **94, 95**

Studio M D **148, 150**

The Townsend Agency **124**

Veronica Graphic Design **21**

Elton Ward Design **29, 32, 89, 98, 99**

Watt, Roop & Co. **24, 28, 31, 61**

Wolfram Research Publications Department **39**

Zubi Design **92, 93**

Designer Index

Anderson, Jack **30, 33, 34, 35, 36, 38, 49, 60, 61, 65, 96, 100, 101, 102**

Anicker, John **35, 102**

Balouch, Kristen **92, 93**

Balouch, Omid **92, 93**

Bates, David **35, 38, 49, 60, 96**

Bednarek, Ellen **90**

Benson, Elaine **133**

Benzon, Darlene **77, 78, 79**

Branson-Meyer, Bruce **30, 102**

Breiderbach, Jeff **64**

Brown, Ron **21**

Bustamante, Jill **102**

Carter, Greg **113,**

Cerveny, Lisa **18, 19, 34**

Chung, Cliff **60**

Cover, Gail **56, 58**

Danne, Richard **19**

Dean, Paul **72**

De Lisen, Chris **89, 98, 99**

Dixon, David **74**

Dominiak, Jason **32**

Edwards, Bruce **21, 25, 37, 60, 88, 91**

Eggers, Scott **60, 101, 103**

Eliason, D. **40, 43**

Favour, Heidi **65, 102**

Fenster, Diane **154, 155, 156, 157**

Figueroa, Iesa **12**

Franklin, Dan **82, 91**

Garre, Meredith **16**

Gillespie, Laura **83**

Gonztlez, Dan **84, 114, 115, 116, 117**

Haddon, Suzanne **18, 19, 34**

Hampton, Debra **33, 100**

Hermes, Mary **30, 36, 101**

Higbee, Annie **67, 70, 71, 107, 131**

Higgins, Corey **105**

Hornall, John **18, 19, 36, 102, 103**

Hutchinson, Mary Chin **30, 36**

Idleman, Scott **10, 11, 12, 15**

Jariya, Peat **63**

Johnson, Peter **81, 86,**

Keenan, Julie **30, 36, 38**

Klein, Chuck **115**

Krupsky, Steve **22, 23, 90, 118,**

Lam, Eric **108**

Lange, Jim **23, 110, 111, 112**

LaPine, Julia **96, 102**

Lipner, Robin **142, 144, 145, 146, 147**

Lock, Julie **30, 61, 65, 96**

Lofgren, Jennifer **39**

Lufrano, Rosanne **95**

Macrae, Simon **29, 98, 99**

McClard, Jeff **38**

McGlothlin, Gordon **74, 75**

McGouch, Mary Evelyn **69**

McKay, Fran **103**

Merk, Robert **12**

Mitsui, Glenn **148, 150**

Modelhart, Herbert O. **9**

Monroy, Fernando **56, 57, 58, 59**

Morris, Steven **20, 73, 85**

Morris, Ken Jr. **112**

Namaye, Darren **20**

Ng, Lian **61**

Nicholson, Philip **136, 137, 138, 140, 141, 142, 143**

Oznowich, Gregory **31, 61**

Pereira, Eduino J. **132**

Perkins, Robin **64**

Peterson, B. **40, 43**

Pham, N.T. **40, 43**

Posey, David **22**

Potocki, James **37, 134**

Prugh, S. Jeffrey **28, 31**

Ray, S. **40, 43**

Raymundo, Leo **33, 36, 60, 65, 100, 101**

Raynard, Nicole Crameri **153**

Rezac, Ross **14, 86**

Riddle, Lynn **12**

Riordon, Shirley **13, 17**

Romanuck, Marcia **103, 104**

Roscoe, Kurt R. **31**

Sabin, Tracy **29, 50, 51, 52, 53, 54, 55, 116, 120, 121, 122, 123, 124, 125, 126, 127, 128, 129**

Salisbury, Mike **21**

Santos, Beth **41, 62, 85, 130**

Satloff, Cynthia **153**

Scarpulla, Zina **95**

Scheel, Allison **103**

Schipp, Andrew **32**

Schumer, Arlen **152**

Shimokochi, Mamoru **94, 95**

Skoro, Martin **14, 86**

Sowash, Randy **72**

Spada, Sergio **68, 76**

Tasnadi, Veronica **21**

Torres, Felicío **26, 27**

West, Ross **45, 46, 47, 48, 49, 57**

Wheaton, Dan **13, 16**

Williams, Stewart **82**

Wilson, J. **40, 43**